HIROSHIGE

MASTERWORKS OF UKIYO-E

HIROSHIGE
FAMOUS VIEWS

by Muneshige Narazaki

English adaptation by Richard L. Gage

KODANSHA INTERNATIONAL LTD.
Tokyo, New York & San Francisco

Distributed in the United States by Kodansha International/USA Ltd. through Harper & Row, Publishers, Inc., 10 East 53rd Street, New York, New York 10022.

Published by Kodansha International Ltd., 12-21, Otowa 2-chome, Bunkyo-ku, Tokyo 112 and Kodansha International/USA Ltd., 10 East 53rd Street, New York, New York 10022 and 44 Montgomery Street, San Francisco, California 94104. Copyright © 1968 by Kodansha International Ltd. All rights reserved. Printed in Japan.

LCC 68-26557
ISBN 0-87011-068-3
JBC 0371-780678-2361

First edition, 1968
Eighth printing, 1981

Contents

Adaptor's Preface

THOUGH SOME of the ukiyo-e print designers who were working in eighteenth and nineteenth century Japan are generally acknowledged to be among the world's greatest artists, it is sometimes mystifying to the Western reader that the image of their lives is in most instances blurred and ill-defined. In the case of Hiroshige—whose biography is well documented in comparison to some of the other well-known ukiyo-e artists such as Sharaku and Harunobu—we know the bare details of his life but lack direct knowledge of the personality of this great landscape artist.

Why is it that there is considerable information on the lives of the great European artists such as Turner (1775–1851) and Delacroix (1789–1863), who were working in Europe at roughly the same period, whereas for most people today Hiroshige (1797–1858) is less a personality than a label on a large number of fine landscape prints? Though a complete answer would involve a comprehensive description of Japan in Hiroshige's day, the following factors serve as a partial reply and at the same time throw light on the role of the ukiyo-e artist.

Firstly, the ukiyo-e artists were artisans designing pictures for popular consumption. Their public for the most part had no special respect for "art" as such but were interested in the prints for their novelty and content—in the case of Sharaku's portraits of actors the prints give a record of the popular theater of the day, and Hiroshige's landscapes gave the people of Edo a picture of the country in which they lived, which, because of the limited transportation facilities of the time, they seldom had the opportunity of seeing for themselves.

The ukiyo-e artist was commissioned by a publisher and sometimes, for instance in Hiroshige's Kisokaidō series, the publisher had considerable influence on the artist's choice of subject. The artist—though he naturally played the most important role in the creative process—was only one link in the total production of the print. The quality of the print also depended to a large extent on the skill of the engraver. The printer, too, played a vital role—particularly in the case of the work of an artist such as Hiroshige, which depended so much on subtle gradations of color, which were the domain of the printer.

The aristocracy, which patronized the Kanō school of art, had little interest in ukiyo-e. In Europe, on the other hand, it was often the case that the artist would be patronized by a member of the aristocracy. Turner was a member of England's most lofty art institution, the Royal Academy.

It seems that the ukiyo-e artists did not question their humble role. In their highly structured society they did not consider themselves pioneers of taste or leaders of an intellectual elite. Perhaps this accounts for the fact that those diaries that are preserved today are usually no more than brief matter-of-fact notes containing few clues to the artist's ideas on art or to the society in which he lived. Hiroshige's travel diaries contain some amusing comments on the sort of places at which he passed the night on his journeys and how he felt the next morning after a night of drinking, but there are no references to his art. Whereas, the diaries of Delacroix not only provide extensive and direct knowledge about the life of the artist but also an illuminating commentary on the social, artistic and intellectual climate of the time.

Furthermore, the structure of the art business was very different in Europe and Japan. In France or England the independent artist would most often sell his works privately or as a result of a public exhibition, and as a consequence the gallery catalogs, many of which are preserved today, provide valuable references to artists and their work. But exhibitions as they were known in the West were not held in Japan until the early Meiji period. Nor was art criticism, as it developed in early nineteenth century Europe, prevalent in Japan at this time—Hiroshige, unlike Turner, had no Ruskin to extol his talents.

But though the ukiyo-e artists were businessmen in a sense—not "garret types" —they did not always make even a moderate income from their art and even Hokusai at one time found himself selling candy along the banks of the Sumida River. Moreover, Hokusai and Hiroshige, who are generally held to be the greatest of the nineteenth century ukiyo-e artists, both died penniless. (Hiroshige's will contains passages explaining in detail how the mortgage on his newly bought house should be paid off. Hokusai, toward the end of his life, wrote to his publisher asking for money, saying that he had not even enough clothes to keep him warm.)

In short, ukiyo-e art had little prestige in nineteenth century Japan; and the low status of the artist is reflected today by the fact that the knowledge we have of their lives is relatively scanty.

R. L. G.

Poet Peregrine

THIS SHORT biography of one of the best known and prolific of Japan's ukiyo-e painters I have called "Poet Peregrine." For Hiroshige is an artist of travel and travelers; and his sensitive and compassionate approach is that of a poet. Just as the poems of the famous seventeenth century haiku poet Matsuo Bashō, so Hiroshige's pictures stop nature at a point in time and hold it up for the world to see —restful or restive, serene or stormy, and always beautiful. Also like Bashō, Hiroshige's work was inspired by what he saw on his many trips through Japan— a country that both poets have shown to the world through their art.

Andō Tokutarō, later to achieve fame under the name Hiroshige, was born in 1797 in Yayosugashi, in the vicinity of what is today Tokyo Central Station. Unlike most ukiyo-e artists who came mostly from very humble origins, Hiroshige's family was one of moderate respectability—a factor that partially accounted for the elegant tastes which the artist was to retain throughout his life. As an official fire warden, his father Genuemon held a position of some status in a city like Edo where fires were distressingly frequent and the fire service one of some glamor and prestige. This position, which he had inherited from his father and which his son and grandson were to inherit in their turn, gave Hiroshige a steady source of income on which he was able to live for a time while devoting most of his attention to his art.

Sadness and loneliness, characteristics that were later to show themselves in his work as an artist, came early in Hiroshige's life. In the second month of 1809 Hiroshige's mother, a lady whose exact lineage is uncertain, fell ill and died. As a sensitive young boy of thirteen, perhaps just beginning to dream of his future, this was naturally a bitter blow. But his grief was doubly compounded when his father, after passing on his position as fire warden to his son, died in the same year. The scar left on his mind by being so suddenly orphaned was to be reflected in his emotional disposition, his view of humanity and his work as an artist.

For fifteen years Hiroshige carried out the duties of fire warden. But when he was twenty-seven he handed the position to his young cousin Tetsuzō. (Later

Hiroshige's only son Nakajirō was to assume the position.) Though he was not interested in the family occupation, Hiroshige had done his duty as was necessary for the sake of his parents and so as to be able to retain the privileges that the position gave the Andō family. But, as soon as convenient, he divested himself of the burden to devote all his time to the career of his choice.

Hiroshige's first formal art studies had begun at the age of 15, in 1811, with a teacher who was not apparently the first preference of the aspiring young artist. It seems that Hiroshige had wanted to study with Toyokuni, one of the most famous artists of the important Utagawa school, but, for reasons that are not entirely clear, this was not possible and he entered instead the house of another artist of the Utagawa school named Toyohiro. (Perhaps Toyokuni, an extremely fashionable artist, had more pupils than he could handle and was unable to take in Hiroshige. Or perhaps the reasons were more complicated concerning the relations between Toyohiro and Toyokuni; it seems that the two artists had had some sort of quarrel and had recently come to terms with each other, and as a token of his sincerity Toyohiro had sent his favorite son Kinzō to study under Toyokuni. Possibly, in return, Toyokuni sent Hiroshige, even then clearly a young artist with a brilliant future, to Toyohiro, whose pupils were few. A third theory is that Hiroshige met Toyohiro through the kind offices of a library owner.)

In some ways it is perhaps fortunate that Hiroshige did not study under Toyokuni. In his studio at that time were already such noted artists as Kunisada and Kuniyoshi, and had Hiroshige worked with them it is unlikely that he would have had the freedom to develop that he enjoyed under Toyohiro, whose students then included no one of outstanding talent. Toyohiro himself, a man of gentle and retiring disposition and the antithesis of the fashionable and stylish Toyokuni, was a man of some genius with wide interests extending beyond the woodblock print to literature and painting of the "official" Kanō tradition. Both artists had studied under the founder of the Utagawa school, Utagawa Toyoharu, a man of considerable importance in the history of the woodblock print. Although probably as talented as the great artists of the golden age of ukiyo-e—Sharaku, Kiyonaga, Utamaro, Shunjū, Eishi—Utagawa concentrated on teaching. He is noted for the introduction of Western-style expression in landscapes and the development of perspective.

Whatever the circumstances that led the young artist to study under Toyohiro, it is clear that Hiroshige showed immediate talent as an artist. Up to this time he had been using the name Tokutarō, but so apparent were his skills that, only one year after he began studying, Toyohiro gave him the honor of being able to use the school name, Utagawa, and began to refer to him as Hiroshige. ('Hiro' was taken from the second part of Toyohiro's name according to the custom of the time.) But it was not until September, 1813, that the artist signed himself Hiroshige, a name destined to appear on a vast number of works of art.

At this point it would be helpful to explain to the reader something about the practice of name changing and the names used by Hiroshige. A change in name was usually made when some event of great importance occurred. As a young boy Hiroshige was called Tokutarō and there are some works drawn by him at the age of ten bearing this name. When he assumed the position of fire warden he changed his name to Jūemon and in his late years he altered it again to Tokubei. But the artist used the name Hiroshige to sign his work from the time he was studying under Toyohiro until his death, so the names on prints are not helpful in classifying his works into periods as they are in the cases of some other artists. However, he did employ a number of other pseudonyms simultaneously with Hiroshige, which provide great assistance in both the dating and the understanding of his work. The first of these pseudonyms, Ichiyūsai, appears in 1813, when the artist was only seventeen, and continues to occur to 1829, the length of the period indicating the difficulties Hiroshige encountered in establishing himself as an artist. The second pseudonym, also pronounced Ichiyūsai (or Yūsai) but written with different characters, occurs for a short period between 1830 and 1831. A third written version of Ichiyūsai was used between 1832 and 1850 and the name Ryūsai was used between 1850 and 1858. We shall see later that these dates mark important changes in Hiroshige's life and work.

Hiroshige studied under Toyohiro only for a little less than one year, apparently unable to quench his thirst for knowledge and skills under the tutelage of this artist. Though he did not completely break his link with Toyohiro, he probably wanted to spend more time studying Kanō art to which, in all likelihood, he had already given some attention. Moving from one school to another was frowned upon by the Kanō school itself, but it was a little more acceptable in the freer world of ukiyo-e and in all likelihood Toyohiro, a sympathetic and versatile man, offered no opposition to Hiroshige's decision to learn from other teachers.

The Kanō school of art employed Chinese painting methods. The spirit of Kanō art is Confucian, and partly for this reason it became the "official" art of the Tokugawas, whose philosophy and way of life were rooted in the Confucian ethic. Kanō painting masters were stationed throughout the country in the castles of the daimyo, and artists trained in the strict, stylized and formal traditions of the school were considered to be the elite of the art world at that time.

Hiroshige's teacher of Kanō art was Okajima Rinsai. Rinsai, also a fire warden, was for a time an official at Hiroshige's house and it seems probable that Hiroshige began studying with him at an early age. The strong, black Kanō line in some of Hiroshige's paintings made at the age of twenty, and the fact that Hiroshige was apparently already a highly capable artist by the time he studied under Toyohiro, bear out this assumption.

Hiroshige next studied a softer, personal school of painting called the "southern style" under Ōoka Umpō, who had himself studied under an important painter

named Tani Bunchō. It is not certain when Hiroshige worked with Umpō, but the influence of this master is clear in Hiroshige's strongly personal approach to natural subjects.

Western painting techniques also had an important influence on Hiroshige, as indeed they did on other Japanese artists of this time. An enthusiastic and self-taught admirer of Western painting methods, he used Western perspective and the Western naturalistic approach in his landscapes—a fact that must be fully appreciated if the work of this artist is to be properly understood. At the same time Hiroshige learned from the Shijō school, which endeavored to apply Chinese painting techniques and methods to a Japanese context. This school, most of whose artists concentrated on Kyoto scenes, was founded by the painter Goshun. The realism of their style of painting, similar to that which ukiyo-e artists used in depicting Edo scenes and life, suited and appealed to Hiroshige. It is not known with whom he studied and it is probable that he taught himself all that he absorbed and learned from the Shijō School.

In spite of his abilities Hiroshige, as an aspiring young artist, had to struggle to raise his head above the crowd and it was only after many years of perseverence that the artist found his forte and achieved the public recognition that his talents merited. The ukiyo-e field was one in which it was particularly difficult to establish a reputation; there were a vast number of painters (particularly in the Utagawa school) and the product that they were creating, the woodblock print, was often a mass-produced consumer article the quality of which depended greatly on the block-makers and the printers. Furthermore, Hiroshige, like most ukiyo-e artists of the day, had to spend the bulk of his time on pictures of beautiful women and warriors, and illustrations for literary pieces—subjects for which his artistic abilities were not best suited.

Although Hiroshige apparently expended considerable time and effort on the popular type of *bijin-ga*, "pictures of beautiful women," his talents did not lie in this field. What is more, the trend of the times was moving away from the gentle, refined, idealistic portrait—which Hiroshige made—toward a more sensual, vulgar picture. But as he persevered in this genre, Hiroshige's pictures gradually came to resemble the less evocative portraits of the aristocratic Eisen—whose work Hiroshige admired—though his inability to infuse his women with sensuality eventually caused him to abandon this field and pursue another course.

In 1830, Hiroshige boldly decided to make a complete change of subject. He resolved to concentrate solely on landscapes and pictures of birds and plants (*kachō*). Though he had done pictures of the kind before, they had been derivative. He now determined to discard his old style, and develop his own view of the natural world. In token of the change in attitude, he took the name Ichiyūsai, as we have already noted, pronounced the same as his former pseudonym but written with different Chinese characters.

In the bird and plant series of this period, most of which are accompanied by poetry, Hiroshige, despite a certain lack of polish, achieves a pleasing color harmony and a distinct and individual freedom from formal restraint. Among the landscapes, most notable is the series of ten impressive and powerful *ōban* versions of "Famous Places in the Eastern Capital," a fluent, if as yet somewhat immature set of views of Edo. Hiroshige's use of perspective in these pictures is sincere, natural and not intellectualized. The lines are sharper and more youthful than in his later works, the wash coloring of the sky is melodic and harmonious, and the treatment of locale and people reveals Hiroshige's love of nature and compassion for humanity. These ten prints represent the essence of the style and approach that was to remain with the artist throughout his working life. In these two brief but important years, Hiroshige acquired confidence in himself as an artist of landscapes and birds and plants, and, as a consequence, his art started to become well known and acclaimed throughout the ukiyo-e world.

In 1832, Hiroshige, now aged thirty-five, once again changed his pseudonym, this time to Ichiryūsai, indicating his maturity as an artist. During the years in which he has used the name Ichiyūsai he had studied and worked to improve his style and to sharpen his perception of the world around him. Now he felt the groundwork was laid. Though something of Hokusai's influence is discernible, the earlier pictures of this period clearly reveal the path Hiroshige had selected. Later, all influence is subordinate to Hiroshige's own expressive powers, and an innate lyricism, present in him from his childhood, becomes gradually more and more apparent. In his bird and plant pictures of this period we find him striving to simplify and abbreviate line and color.

The bird and plant pictures of this period, I feel, represent the pinnacle of Hiroshige's artistic growth. The gentle warmth and love we see in them grew, perhaps, from the love that Hiroshige had acquired for the isolated beauty of nature. These were the seeds from which later was to grow the warmth of feeling that infuses his great landscapes. During this period Hiroshige did a series of prints of fish, which are lovely, if a little stiff and biological. The series accompanied a set of poems, and the restrictions set on them by the verse and the fact that they had to be made in a specified order may well have cramped the artistic style. They did, however, give Hiroshige prestige as the first artist to realistically represent fish in the medium of the woodblock print.

It was a trip made in 1832, from Edo to Kyoto, along the Tōkaidō ("Eastern Seaboard Highway") that inspired the series of pictures that suddenly and firmly established Hiroshige's fame as a landscape artist. They are, of course, the internationally known "Fifty-three Stations on the Tōkaidō." Hiroshige began his trip —one of so many that he was to be known later as the "Poet of Travel"—in the eighth month of 1832. His decision to go then arose from a number of factors and may have had some connection with the annual dispatch of horses to participate

in the Komabiki ceremony held each summer at the Kyoto Imperial Palace. On this occasion Hiroshige toured around the Kyoto environs before returning to Edo. During his travels he always kept a pictorial diary, and after this particular trip the pictures in that diary became the basis for the "Fifty-three Stations" prints (fifty-five horizontal ōban prints in all, completed in the first month of 1834, and published by Hōeidō).

Many people had talked and written about the famous Tōkaidō, but Hiroshige's approach to it was to tell of the life in the country, of the travelers themselves, and most of all to capture the natural beauty of the scenery along the way. The matchless full moons, the snows, the mountains in mist, the pines, the moon-gilded cherry blossoms, and the dancing waves glittering in the sun, all this in a purely Japanese vein, was calculated to appeal to an age-old Japanese love of nature. When the prints appeared on the market in Edo, they were an instantaneous success. The lyricism, the economy and strength of line, and the distinctive color captured the hearts of the Edoites. So great was their popularity, that Hokusai, then on a trip in Shinshū (now Nagano Prefecture) hurried back to Edo to turn out his "One Hundred Views of Mount Fuji" in an attempt to bolster his threatened position as the nation's leading landscape artist. It was, however, too late. The times were out of joint for the older master's powerful intellectualism. Hiroshige's warmth and gentleness had seized both the hearts of a grateful public and the pocketbooks of the affluent publishers—an unassailable combination.

On the crest of this wave of popularity, Hiroshige began to turn out a large number of prints. The "Eight Views of Ōmi" (eight prints, horizontal ōban, published by the Eikyūdō and the Hōeidō) is a successful, harmoniously colored evocation of views of the area around Kyoto and Lake Biwa. Though throughout the set the slender line results in a loss of power, the composition is skillful and the color bright and rich. The "Famous Places in Kyoto" (ten prints, horizontal ōban, published by Eikyūdō) appeared in 1834. To a man born and bred in Edo, bounded by plains and the sea, these pictures of the ancient capital city, nestling in a basin among rolling green mountains and wrapped in the glittering culture of the age-old court must have come as an enrapturing surprise.

Naniwa (Osaka) supplied the material for another series entitled "Famous Places in Naniwa," but just as Osaka today is an unlovely city, so apparently was it then, for it failed to inspire Hiroshige to a single really good print. Though Edoites who had never been to Naniwa probably found the series an interesting source of information. Several series of prints produced at this period showing famous places in and around Edo contain many masterpieces and reveal important aspects of Hiroshige's art.

The popularity of Hiroshige's work at this time is, no doubt, largely accounted for by its vitality and realism—elements hitherto unusual in Japanese art. Chinese art had exerted a strange influence on Japan, and the literati painters of the Edo

period would make ink paintings of places in China famous for aesthetic or philosophical reasons but known firsthand to practically no one in Japan. But the person looking at Hiroshige's landscapes knows, or feels as if he knows, the place and, in his mind, almost becomes a part of the scene. Hiroshige's presentation might seem commonplace, but is all the more intimate and skillful for its accessibility. Not only is sympathy for his subject revealed in his handling of natural objects and scenery but it also enlivens the figures in his pictures as they go about their tasks of weaving, or carpentering or tending the farm. This emotional concern for his subject has made Hiroshige the Japanese artist that lives most vividly in the heart of the people, even today.

In the late 1830's Hiroshige became involved in a series of prints depicting scenes on the Kisokaidō, a highway that, like the Tōkaidō, linked Edo and Kyoto, but unlike the bright and cheerful seaboard route, passed inland over rugged mountains and deep, sparsely inhabited valleys. The series was originally planned at the time when Hiroshige's "Fifty-three Stations on the Tōkaidō" was making such an impact on the art-buying public of Edo. At first the noted ukiyo-e artist Eisen embarked on the project for the publisher Hōeidō. Eisen, who because of his Chinese style was well suited to portraying the rough, mountainous terrain, planned a grand series of seventy pictures, but he never finished them—perhaps because the Kisokaidō's lack of general appeal was making the venture a loss for the publisher. The series originally started with the pictures being published in order along the route, but when it became obvious that they were not going to be good sellers, the publishers decided to skip around and pick the best views. At this point, the aid of the now-famous Hiroshige was solicited, and over the next few years, he did a number of prints for the series, which required six years to complete. Of the forty-six prints he did for the series, many are serene masterpieces depicting in kindly and affectionate terms the life of the country people.

We have already noted the grief and sorrow that Hiroshige experienced early in his life, which had its effect on his artistic temperament. In 1839 another personal tragedy occurred with the loss of his wife; and in 1841 Hiroshige was deeply disappointed when his only son Nakajirō gave up the family occupation. (He died four years later.) After his first wife died Hiroshige married the sixteen-year-old daughter of a farmer. It must have been a further misfortune in the sad life of the artist when his second wife's brother, a priest named Ryōshin, was defrocked for having an illicit association with a woman and banished from the area.

Though naturally these events affected the artist, possibly the largest influence on the later period of Hiroshige's life was his fame as a well-known artist. The productivity of such ukiyo-e masters was subject to the control of the publishers and to the demands of the public who paid for the pictures. This dual pressure drove artists of Hiroshige's ability and popularity to produce a large quantity of work. A man of forty years with an establi hed position and a stabilized way of

life should be able to concentrate on producing what he wants, but this is rarely the case. The constant need to paint more and more pictures reduces an artist's spiritual content and results in a facile quality in his work. Hiroshige found himself turning out as much material as the publishers demanded and only in his own free moments could he concentrate on creating a few high-quality pieces.

From the time of Hokusai's death in 1849—an event that greatly saddened the ukiyo-e world and one that left Hiroshige undisputed master in the landscape field, Utagawa Toyokuni, leader in the field of actor-pictures, and Utagawa Kunisada, the best-known designer of warrior—pictures Hiroshige traveled much in search of material and certainly turned out a very large number of print series, including more work on the Tōkaidō. He used the name Ryūsai exclusively from 1850.

Hiroshige's personality is best understood not only by reference to the biographical facts of his life but by examination of his work. Three triptychs, dated 1857, portray, for me, the essence of Hiroshige's character and represent a high point in his career as an artist: "Whirlpools at Naruto," "Moonlight at Kanazawa," and "Mountains and River on the Kisokaidō." These he did at the age of 61, at a time when he was no doubt looking back over his life. His path to success had not been easy and his personal life had been chequered by personal grief. He had lost both parents at an early age and now his wife and son were gone as well. He remained a lonely traveler. All of his life he had sought peace and tranquillity in which to work, but had been confused and his life had been made hectic by the constant struggle to keep up with the demands of the publishers and the public, and by his personal misfortunes. In these three masterpieces, perhaps recognizing that some of his past work had been too hastily produced, he regains the control and mastery that had sometimes been denied him by the turbulences of his life. Not only do these pictures represent a pinnacle of Hiroshige's own creative satisfaction but they are also a landmark in Japanese landscape art. No man's life is entirely praiseworthy and no artist's works are all masterpieces. It is enough that an artist leaves to history one great work. Hiroshige did much better. In the "Fifty-three Stations on the Tōkaidō" and the "Famous Places in the Eastern Capital" he created a new style; in these three masterpieces of his last years he produced a microcosm of beauty, and a distillation of his own personality.

Edo was Hiroshige's home, and he loved it. He was constantly finding in the city new places and new activities, which he put down on paper and preserved for us to enjoy today. Even at 62, he continued that work. In that year came a series entitled "Famous Places in Edo" (45 prints, horizontal ōban, published by Yamadaya) and a second called "One Hundred Views of Famous Places in Edo" (118 prints, vertical ōban, published by Uwoei).

The latter contains three prints by Hiroshige's pupil Shigenobu, an undistinguished artist who was later to marry Hiroshige's adopted daughter and take the

name Hiroshige II. Just as the portions of Mozart's *Requiem* that are said to be the work of one of his pupils are the best work of that little known composer, so the three pictures in the Edo series are the greatest ever to come from the hands of Shigenobu.

The prints in the Edo series, though not all great, are fresh and beautiful. Enlargement of foreground elements in contrast with the background is more pronounced than in earlier works. We do not know for sure when the camera first came into this country, but the photograph captured the public attention by the year 1854. Photography could have supplied Hiroshige with a hint for this treatment of perspective. Dark color and great care to achieve tonal harmony also distinguish these prints, which enjoyed unprecedented popularity. They went through many editions and were published as late as the Meiji period. But the later prints, as might be expected in such a decorative series, compare most unfavorably with the earlier ones.

Though great popularity cheered the old man and inspired him to increased activity, tragedy was close at hand. The year 1858 was one of unsettled weather. Cholera raged through the capital from the summer into the autumn. Poor preventative medicine and treatment increased the number of cases of the disease till, some say, as many as twenty-eight thousand died in Edo alone. Hiroshige, too, fell victim. On the morning of the sixth day of the ninth month, at the age of 62, he died. His farewell poem reads,

> Leaving my brush on the Azuma road,
> I go to see the famous sights
> Of the Western Paradise.

Azuma road is an illusion to the Tōkaidō, which inspired Hiroshige's finest work.

Hiroshige's tombstone was in Togaku Temple in Kitamatsuyama, Asakusa, but later the temple was moved outside Tokyo where few people could come to pay their respects. His tombstone disappeared completely when the temple was destroyed by fire, but nothing can destroy the glowing love Hiroshige continues to earn from all people who enjoy beauty.

Famous Views

Edo

Two Poetic Approaches

It seems likely that Hiroshige produced in all twelve hundred to thirteen hundred prints in the many series he made of places in Edo and that he used 152 different locales. The center of the city provided the subject for most of his landscapes, but the overall territory that his work covers extends to Haneda, where the Rokugō River flows into the bay, the Tama River embankment, Koganei, Inokashira on the southeast, to Kōnodai and Susaki along the Edo River and to Mikawajima and Ōji in the north. The sheer number of his Edo prints and the great variety of places in the city that they depict are as much an indication of his fondness for Edo as they are a result of the pressure of public demand for his work.

Hiroshige maintained a lucid and simple style, avoiding intellectualism and never attempting to hoodwink his public with trick effects. He used his colors with the intention of giving pleasure to the viewers of his work; indigo skies and water are simple and direct in their appeal, morning mists, snows, rains, sunsets, moons afloat in night skies, zigzagging lines of geese, and the whole glittering spectacle of the capital create a rich and intense picture of daily life. In Hiroshige's world, people accept without suspicion the joys and sorrows of existence. They live to life's limits without falsehood and evil. The famous places in their city, the way they themselves walked, danced, laughed, cried, live for us today because Hiroshige, moving through all planes of his Edo, recorded it as it was—but will never be again.

Hiroshige painted the charms of his capital city with a rich and gentle enthusiasm. Edo was the place of his birth, in Edo rested the remains of his parents whom he had lost at a young age. One would expect that the capital should be the city he chose as the place in which to seek his fortune. He has left us a complete and sympathetic portrait of the city as he loved her, loved her so much,

in fact, that the old city as we think of it now is in a very real sense Hiroshige himself. Her hills and rivers, her trees, bridges and houses, the sea beyond, the people, and yet more people, the grass at the edges of the roads, and the very stone over which a drunkard might stumble on the way home from a party, all are the flesh and blood of Edo. All are also the shadow of the artist. All are slightly sorrowful; the sorrow is Hiroshige's sorrow.

In contrast, Hokusai had praised the same city in a song of a different melody with lyrics of another meaning. Although by his forties his Edo works show a certain elegance, his image of Edo is not, on the whole, one of mankind caught up in the fascination of nature; his Edo is rather a stage for human drama, not comedy nor tragedy, but a lusty saga relating the reality of man and his world.

Because much of Hokusai's work was illustrations for books of humorous poetry—many of which were done in his younger days at the time that he was calling himself Sōri, but many more were done after 1798—the verse itself sometimes limited the subject matter of the illustrations. Though in some respects reminiscent of the type of screen painting depicting activities in the city of Kyoto that were popular in that city around 1600, Hokusai's versions of Edo are nevertheless much more vital representations of the robust, bustling life of the city and all its facets in many changing complexions, with its people entwined in a pageant of cherries and maples, dawns and dusks, and the black-and-white of life in a great metropolis.

THE SUMIDA RIVER PRINTS

No scene in Edo so inspired Hiroshige as the Sumida River, which flowed in a blue—at least blue in the Edo period, a sad, grimy gray now—ribbon of water that wound its way among the gayest and gaudiest parts of the capital. Along its banks stood Yoshiwara, the famous licensed quarter, Asakusa, the site of one of the city's most popular temples, and Ryōgoku Bridge, until fairly recently the scene of Japan's biggest yearly fireworks displays.

With such intensely colored skeins to work with Hiroshige weaves a dazzling tapestry. Striving always to capture the moment that symbolizes man in relation to nature, he creates for us a rich cross section of Edo life in the first half of the nineteenth century. We see the stately and richly-dressed courtesans of Yoshiwara against clouds of pink cherry blossom, we hear the cries of street hawkers and fruit sellers—and we shiver in their cold and bask in their warmth. Throughout his work the blue river, symbol of eternity, its every ripple touched with Hiroshige's personality, flows past the citizens of old Edo on its course into history and into the hearts of art lovers throughout the world.

FAMOUS PLACES OF THE EASTERN CAPITAL

This set of ten ōban prints came out in 1831, one year before the trip that supplied

the material for the famous Tōkaidō prints, which established Hiroshige as a landscape artist and vied in popularity with Hokusai's Mount Fuji prints. Though some of the drawing is rough, some of the composition less than excellent and though we detect Hokusai's influence, nevertheless, we sense Hiroshige's calm and compassionate personality at work, and we perceive a richness of artistic talent that promises great things. Whistler found these pictures very moving.

FAMOUS SIGHTS IN EDO IN ALL FOUR SEASONS
Poems accompany these four long, slender representations of famous Edo spots in their changing seasonal garments. Cherries in full blossom at Gotenyama create a picture of spring, while summer finds expression in a watermelon seller in a boat under the Ryōgoku Bridge. Crimson maples at the temple Kaian-ji represent autumn, and a bargeman wearily toiling up the snow-bound Sumida closes the series as winter.

Among the most famous of his small works, these pictures, published in 1834, successfully evoke the feelings of the places they depict. The combination of poetry and picture on one surface, frequent in the Orient, is perhaps odd in the eyes of Westerners. So many ways have the Japanese evolved for combining the two media of expression that they have almost become one. Hokusai's primary concern was compositional form. Hiroshige, concerned with lyricism, is, consequently, more literary in his approach. His pictures of birds and plants, his "Eight Views of the Edo Environs," and this series clearly indicate his poetic outlook.

EIGHT VIEWS OF THE EDO ENVIRONS
These pictures, said to have been published while Hiroshige was also working on the "Sixty-nine Stations on the Kisokaidō," show us eight locations that not only no longer exist in their earlier forms, but that have passed from the memories of most people. We should be grateful that Hiroshige's art has preserved them for us.

ONE HUNDRED VIEWS OF FAMOUS PLACES IN EDO
Hiroshige's last and longest series of pictures came out with great rapidity in the last years of the artist's life, when he had reached a new peak of popularity. Doubtless, with increasing age, Hiroshige pondered on the uncertainty of his remaining years and exerted himself to the limit to record on paper as much of his beloved city as possible. He died during production of the group, which, including some works by his pupil, runs to a total of 118 prints. A somewhat exaggerated enlargement of foreground elements and dwarfing of those in the distance for the sake of perspective distinguishes several of the prints.

Here again, as always with Hiroshige, the main theme is man in his natural

setting, and the series includes the full span of nature from sunny mornings to evening sunsets, from snows to mists, from balmy spring to sultry summer, from golden autumn to frozen winter. Possibly Hiroshige had a chance to peep at Edo through one of the camera lenses then being imported into Japan for the first time. Such a peep would have shown him the old familiar sites in a new and heightened perspective. This may account for the huge soaring eagles and the massive paper lanterns in some of his prints. His willingness to adopt a fresh position, even toward the end of his life, bears witness to his youthful attitude.

The Mountain Path

THE SIXTY-NINE STATIONS ON THE KISOKAIDŌ

Many enigmas surround the long series of prints of the Kiso highway. Not the least puzzling of them is its joint authorship: Ikeda Eisen is responsible for twenty-four of the pictures, and Hiroshige for the remaining forty-five. Possibly Hiroshige did not like the fact that Eisen, not he, was the man chosen to design a long series that was intended to capitalize on the success of the Tōkaidō prints. Perhaps a comment by Hokusai about "whippersnapper artists who know nothing" irritated Hiroshige. We do not know the inside story but we do know that beginning with print number twelve, Hiroshige also starts working on the series. Gradually the number of his works increases until Eisen drops entirely from the scene. Equally strange as the change of artists is the change of publishers. The series began as a single venture on the part of the Hōeidō; then it became a joint venture with the Hōeidō and the Kinjudō; finally, it became a sole production of the Kinjudō. We cannot say why this shifting about took place. Perhaps there was dissension and disagreement between publishers and artists. Eisen appears to have been angry about something, and a clear change in style among some of Hiroshige's later prints might indicate that the younger artist was also.

Though it contains some very fine pictures, the mood of the series is not cheerful. Perhaps this was the result of the discord boiling around the project. But there were also a number of other factors. On the personal side, Hiroshige lost his wife at this period, and his only son, Nakajirō, decided to abandon the family calling. And at this time Japan languished in the grips of one of the worst famines in her history, the great Tempō Famine. The *bakufu* (feudalistic shogunate) had lost some of its former power, and foreigners, long held at bay, rapped hard on Japan's doors with demands for diplomatic relations and permission to trade. Finally the Kisokaidō itself, unlike the well-traveled and much sung Tōkaidō, was a gloomy inland route, which passed over rough and rocky terrain and through sparsely populated areas. A man of Hiroshige's background would not be expected to enjoy traveling alone through such a setting. Considering the troubled situation

of Japan then and what we might surmise of Hiroshige's mood at the time, it is hardly likely that he produce a gay or cheerful set of prints of the highway.

The Open Road

EIGHT VIEWS OF ŌMI
Published by the Hōeidō and the Eikyūdō, directly after the "Fifty-three Stations," these eight prints are among the best of the twenty works Hiroshige did of the Ōmi district. Though they are in the form of the Chinese traditional series of eight paintings, the fresh elegance and distinctive ukiyo-e coloring suffer none for that small nod in the direction of formalized traditional painting.

FAMOUS PLACES IN KYOTO
This set of ten prints is one of Hiroshige's masterworks. They were probably made from recollections and sketches of the trip to Kansai (roughly the area encompassing Kyoto, Osaka and Kobe) that resulted in the Tōkaidō prints, even though that trip was a hurried one and he was forced to refer to other collections for some of his source material. This whole series is technically excellent, rich in mood, and glowing with Kyoto elegance.

FAMOUS PLACES IN NANIWA
Doubtless, when he traveled to the Kansai, Hiroshige also visited Naniwa (Osaka), where he made the sketches from which this print series developed. Although not particularly interesting scenically because of a lack of spectacular topographical features, the pictures possess a liveliness and vigor that Hiroshige was, to some extent, to lose in his late years. These pictures are excellent records of manners and mores of Osaka city life, which was, even then, a great commercial center.

FAMOUS PLACES OF OUR HOMELAND
Complete sets of Honchō Meisho, "Famous Places of Our Homeland," exist. Of the fifteen prints in the series, some were done before and some after the Tōkaidō and the Kisokaidō series. Many of the scenes depicted are from the Tōkaidō area. Of the others, there are some places into which it is doubtful that Hiroshige ever set foot. Possibly, in keeping with the title of the series, he felt he should make his coverage as wide as possible and included a few places totally unknown to him for the sake of breadth.

EIGHT VIEWS OF HYŌRI EKIRO
This is a puzzling set, and the meaning of the title is vague. Published by the Dansendō, its heavy colors are uncharacteristic of Hiroshige's light and pleasing tones.

Sixty-odd Famous Places of Japan

Hiroshige produced descriptive series of many special areas, but in this he turns his gaze on the entire country. The series, a presentation to the people of scenes from their land, is certainly the finest of the sets of the country that were fashionable in the late Edo period. The fact that Hiroshige used other sources for many of the places that he had not visited himself in no way dims the splendor of his achievement. The set is a long one (sixty-nine prints) and contains a great number of very fine works.

The Snow-Moon-Flower Triptychs

We can imagine that at the age of sixty Hiroshige reflected with concern on the time he had spent hurriedly filling orders for demanding publishers and satisfying his admiring public; and, judging from the high quality of most of his work after this time, he determined to strive for greater depth than he had achieved before. The result was the great triptychs—"Mountains and River Along the Kisokaido," "Moonlight at Kanazawa," and "Whirlpools at Naruto"—which give new life and true greatness to the traditional snow-moon-flower symbols of winter, autumn and spring. In these prints Hiroshige regains the mastery of previous years, which he had almost lost by the effort required to produce a large quantity of pictures.

Each of the set is a poetic and impressive three-panel landscape. The Kiso print fills a mass of space with steep snow-swathed mountains, at the bottom of which flows a serene and stately lapis lazuli river, a symbol of eternity. The Kanazawa print is a melody of moonlight, a song to life's lasting and poignant moments sung in terms of a few far-off fishing boats returning to anchor. The final picture, and possibly the finest, is a panorama of the straits at Naruto dotted with whirlpools lyrically treated as large peony-like forms.

Though his untimely death came soon after the publication of these pictures, the triptychs must have given immense satisfaction in the evening days of the Poet Peregrine.

Résumé of Hiroshige's Life

(Hiroshige's age at each entry is given in parentheses)

1797 Born in Edo, the son of Andō Genuemon, a fire warden.

1806 (9) Probably introduced to Kanō-style painting under Okajima Rinsai.

1809 (12) Father and mother die. Hiroshige assumes the duties of fire warden.

1811 (14) Begins studying with Utagawa Toyohiro.

1812 (15) Receives the name Utagawa Hiroshige.

1813 (16) Assumes the additional name of Ichiyūsai.

1815 (18) At about this time studies the "southern" school of painting with Ōoka Umpō.

1817 (20) At about this time learns Western-style painting, probably self-taught.

1823 (26) Passes duties of fire warden to cousin Tetsuzō.

1826 (29) About this time work on beautiful women pictures reduced.

1827 (30) Begins to work exclusively on landscapes.

1830 (33) Secondary name, Ichiyūsai, is written with different Chinese characters from this date; soon changed to Yūsai.

1831 (34) Publisher Marushō issues Hiroshige's "Famous Places in the Eastern Capital." Hiroshige sets new style in the depiction of flowers and birds (*kachō*).

1832 (35) Changes pseudonym to Ichiryūsai.

1833 (36) Publisher Hōeidō issues the "Fifty-three Stations on the Tōkaidō," and Hiroshige becomes immediately famous.

1834 (37) A period of fine work in which the series "Eight Views of Ōmi" and "Famous Places in Kyoto" were published.

1836 (39) New interest in travel and increasing concern with bird and flower prints.

1837 (40) Work starts on the Kisokaidō series.

1838 (41) "Eight Views of the Edo Environs" published.

1839 (42) Wife dies.

1841 (44) Son Nakajirō gives up family position.

1845 (48) Nakajirō dies.

1847 (50) Remarries (to a farmer's daughter named Oyasu).

1850 (53) Takes the secondary name Ryūsai.

1851 (54) Second wife's brother, a priest named Ryōshin, is banished. Hiroshige adopts Ryōshin's daughter Otatsu.

1855 (58) Hiroshige's art reaches peak.

1856 (59) Begins work on the series "One Hundred Views of Famous Places in Edo."

1857 (60) Produces the great triptychs of the "snow-moon-flower" theme.

1858 (61) Dies of cholera.

The numbers that appear on the maps appearing on the facing ▶ page and overleaf refer to the plate number of the print that has that particular location as its subject.

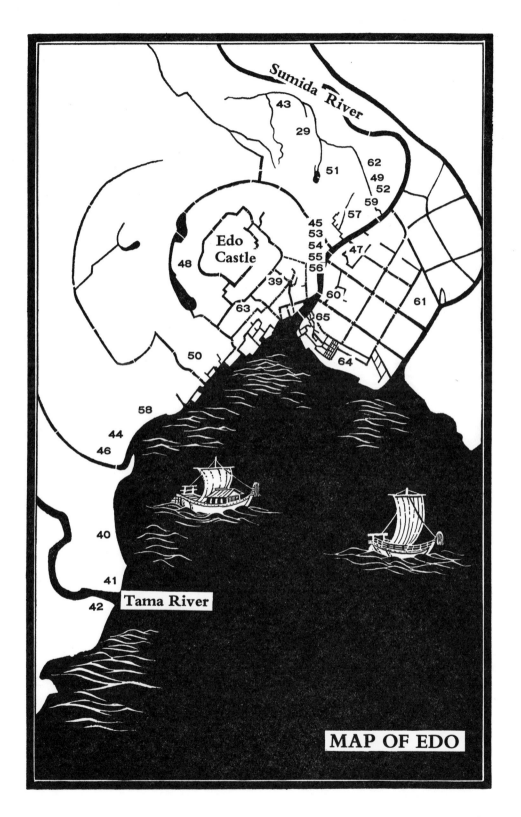

Sumida River

43

29

62
49
51 52
59

45 57
53
54
47
48 55
Edo 56
Castle
39

60
63
65 61

50
64

58

44

46

40

41

42 Tama River

MAP OF EDO

27

MAP OF JAPAN

SIZES OF PRINTS

(The following dimensions are approximate only.)

LARGE ŌBAN 13 × 18 inches (33 × 46 cm.)
ŌBAN 10 × 15 inches (25 × 38 cm.)
AIBAN 9 × 13 inches (23 × 33 cm.)
HOSOBAN 6 × 12 inches (15 × 30 cm.)
CHŪ-TANZAKU 4½ × 14 inches (11.5 × 36cm.)

Acknowledgements:

The majority of the photos in this volume, like those of Volume 3 of this series, "Hokusai," are reproductions from the large collection of Susumu Uchiyama, who has been kind enough to permit us to publish them. We would also like to thank the following persons and institutions for allowing us to reproduce some of the originals in their possession:

Chū Kotaka pp. 84, 85
Toyotarō Takahashi p. 80
Tokyo National Museum p. 72
Hamakichi Murakami pp. 34, 54, 55, 70, 71
Kazushige Higuchi pp. 40, 41
Kinosuke Hirose pp. 44, 45

THE PLATES

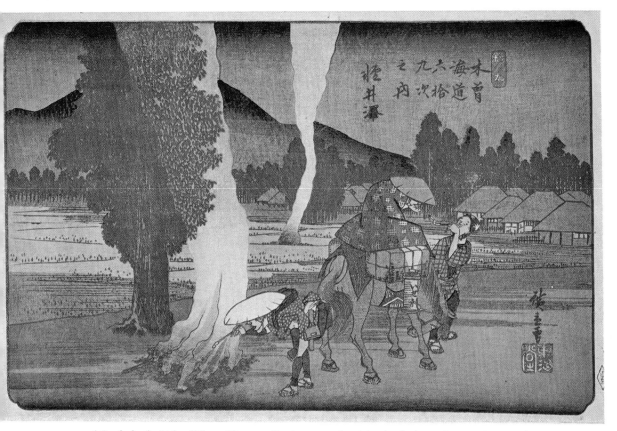

1. *A Smoke by the Light of Fire and Lantern, Karuizawa, the nineteenth station,* from *"The Sixtynine Stations on the Kisokaidō"* ◆ This, and the following Kisokaidō prints (see Plates 1–12) are *ōban* and were published by Kinjudō during the period 1837–1843 ◆ A greenish light gives a lonely mood to this scene of travelers stopping for a smoke under the shadow of Mount Asama. The light from the fire picks out the green of the cedar by the paddy and the paper lantern on the pack horse throws up a patch of blue on the coat of the traveler. Today, the Karuizawa area is spotted with modern villas and carpeted with golf courses.

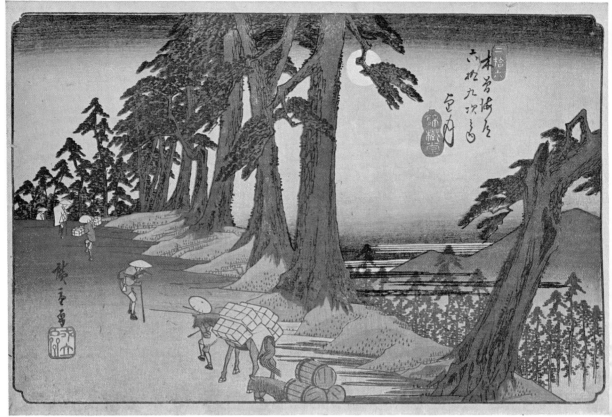

2. *Mochizuki, the twenty-sixth station,* from *"The Sixty-nine Stations on the Kisokaidō"* ◆ The charm of this fine print is as great as the radiance of the full moon which it depicts. *Mochizuki* means full moon and the station was thus named because the horses of the imperial court, which were grazed in open pasture in the mountains above this spot, were returned to court on the fifteenth of Au₃ust, the day of the first autumn full moon. Hiroshige's use of perspective with the row of old pine trees of diminishing size is particularly excellent in this landscape.

3. *Nagakubo, the twenty-eighth station,* from *"The Sixty-nine Stations on the Kisokaidō"* ◆ As an artist of travel and travelers Hiroshige shows his mastery in this well-known print. Rider and grooms cross the Wada Bridge, with heads bowed and clothing drenched in evening drizzle. In the background pale moonlight washes the mountains, forest, sky and water; and in the foreground two village children play with dogs. This beautiful depiction of mountain life alone would be enough to give its creator a position of honor as a landscape artist.

4. *Ashida, the twenty-seventh station,* from *"The Sixty-nine Stations on the Kisokaidō"* ◆ Travelers, on foot and in palanquins, pass a teahouse nestling in a dell on Kasatori Pass, which is a short distance from the Ashida station. The rugged peaks beyond the valley are suggestive of cubism in form and color, a modern treatment characteristic of Hiroshige.

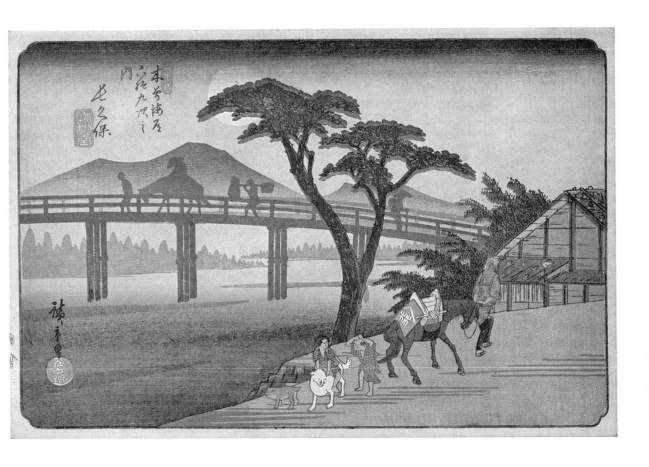

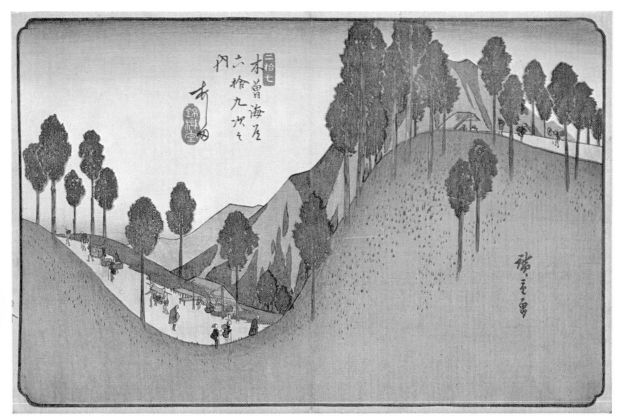

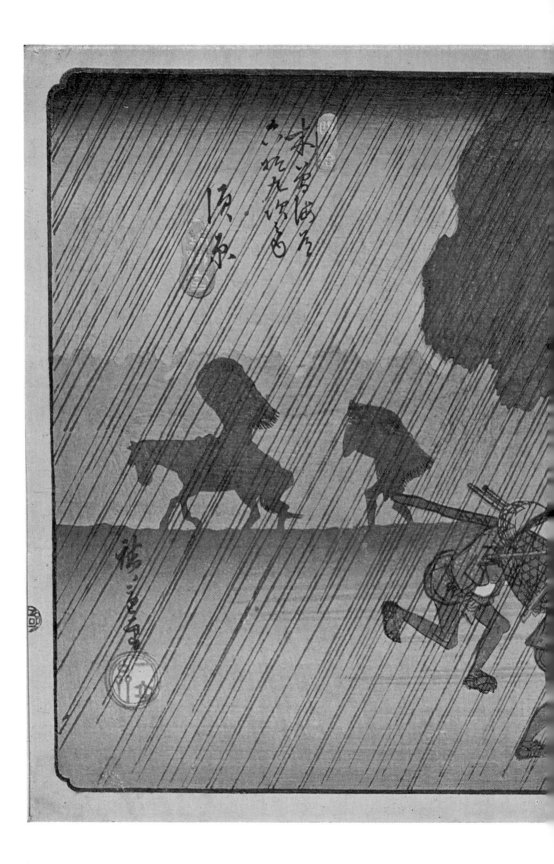

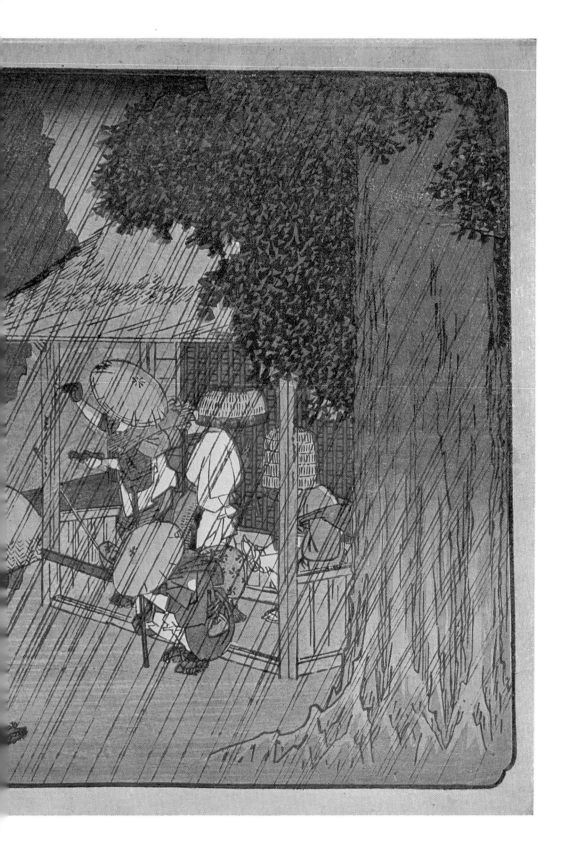

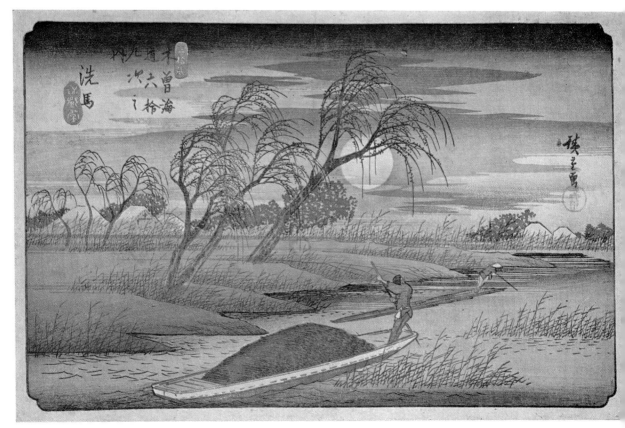

6–7. *Seba, the thirty-second station,* from *"The Sixty-nine Stations on the Kisokaidō"* ◆ Undoubtably one of Hiroshige's finest works is this desolate landscape of a small, moonlit river. (Detail on facing page.) Drooping, wind-blown willows are silhouetted against a large moon and dusky sky; thatched roofs peep over green paddies; and raftsmen pole their rafts through a world where a song would travel for miles on the night air. For whom do the reeds on the riverbank weep? To where does the frail vessel carry its load? These two figures would not exist without the river and moon; all is a harmonious, elegant illusion.

◁ 5. *Suhara, the fortieth station,* from *"The Sixty-nine Stations on the Kisokaidō."* ◆ On a lonely section of the trail travelers shelter and bearers scurry from the pelting rain. In the distance a rider and groom, covering themselves with straw mats, do not stop on their journey. Jōshō-ji, the family temple of a famous late Heian period general, Minamoto-no-Yoshinaka, still stands near this spot, where today giant trees and sharp mountains narrow the road and small houses with stones on their roofs to hold down the tiles retain the picturesqueness of the area.

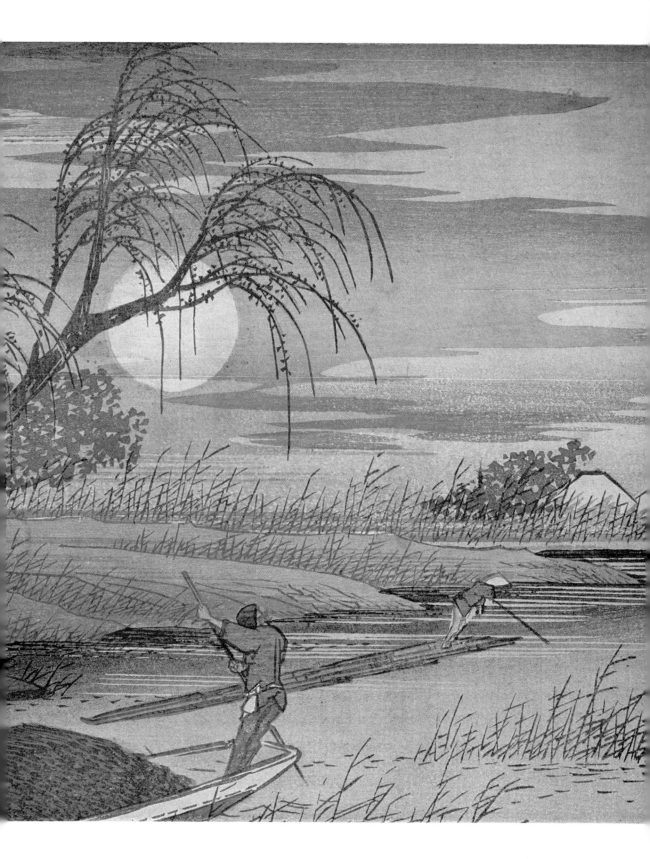

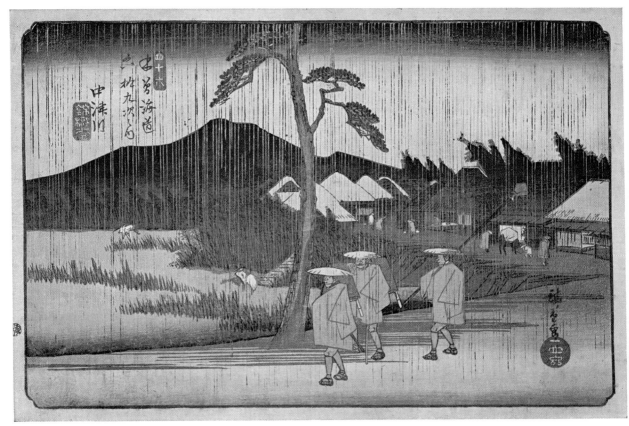

8–9. *Nakatsu River, the forty-sixth station*, from *"The Sixty-nine Stations on the Kisokaidō"* ◆ Hiroshige made two prints of the Nakatsu River. This one (with detail on the facing page) shows the river with lowering black clouds and dark mountains enclosing a yellow sky behind thin threads of rain. White egrets contrast with the blue water, and we can almost hear the croaking of the frogs in the rushes and the fresh green grass. This is one of many examples of Hiroshige's masterful depictions of rain, which have made him known as the "artist of rain."

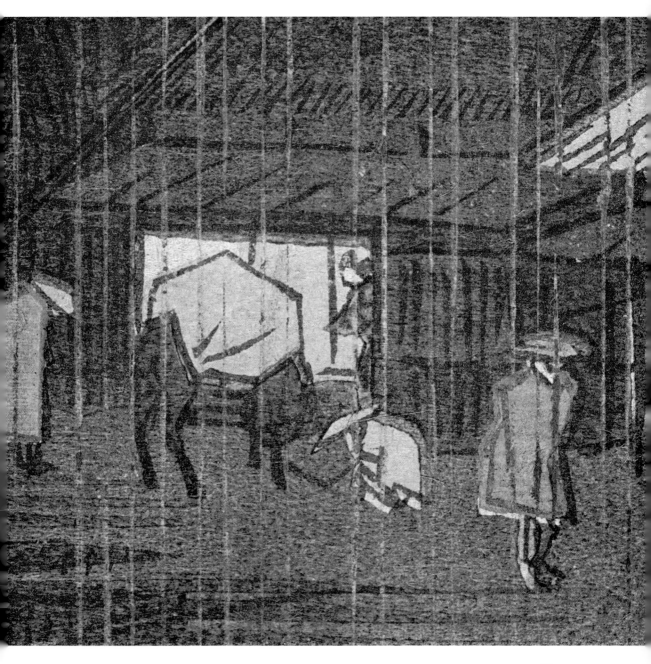

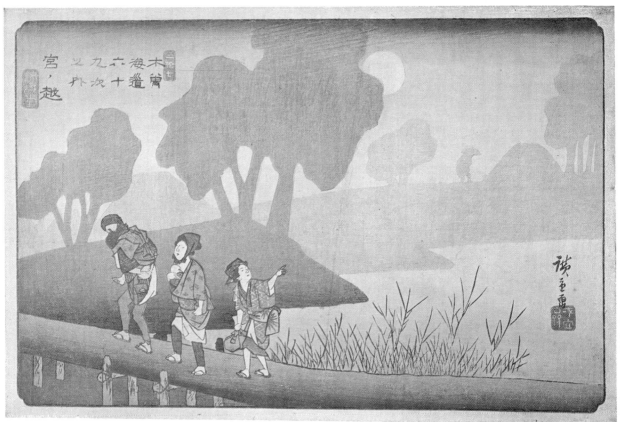

10. *Miyanokoshi, the thirty-seventh station,* from *"The Sixty-nine Stations on the Kisokaidō"* ◆ Hiroshige describes a tragedy in the life of a poverty-stricken family. As a mist-shrouded full moon floods the scene in dismal gray, we can imagine this family driven from their birthplace by destitution making their way to a new living place. Only the daughter turns to look back at what had once been their home. Wreathed in fog and heavy with sorrow, they cross an earth-covered bridge. In the distance an old man, cloaked and broad-hatted, disappears into the chill night mist.

11. *Ōi, the forty-seventh station,* from *"The Sixty-nine Stations on the Kisokaidō"* ◆ Gently curving pines frame this snowscape of deep-white hillocks and weary travelers, their shivering grooms and laden horses. At this point, looking through the Kisokaidō series, Hiroshige's art dissolves our awareness of evil and convinces us that it is the human lot to face up to fate.

12. *Mie-ji, the fifty-sixth station* from *"The Sixty-nine Stations on the Kisokaidō"* ◆ I have long admired this picture for its freshness, though it is not usually considered to be one of Hiroshige's best. Sparrows wheel in the sunset, and the red camellias and lush green bamboo leaves give this landscape a delicate tonal harmony.

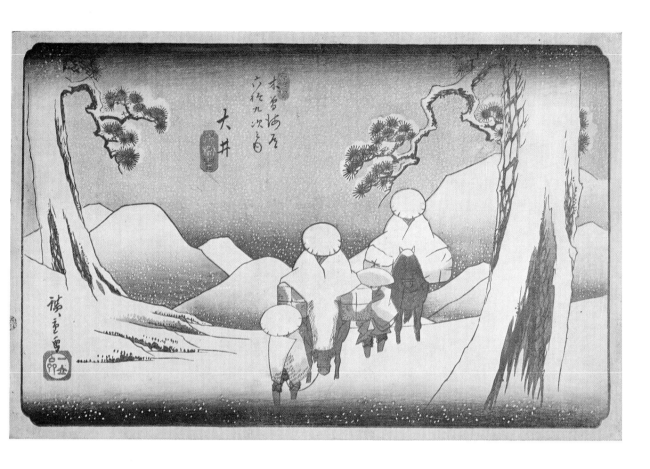

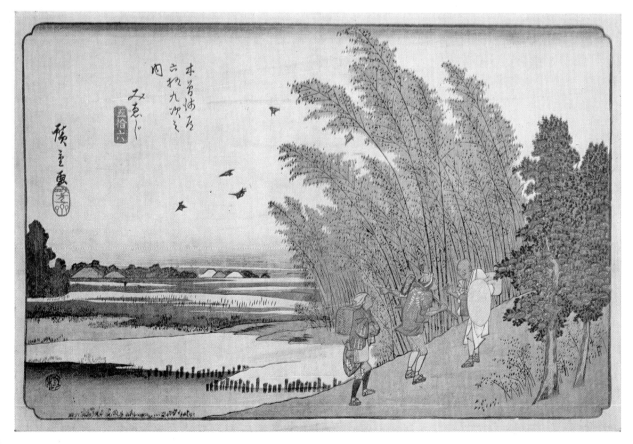

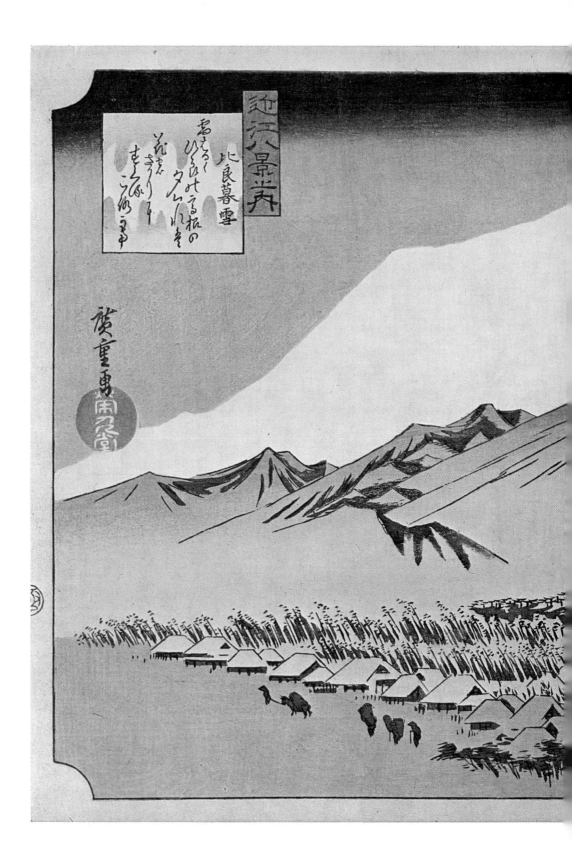

44

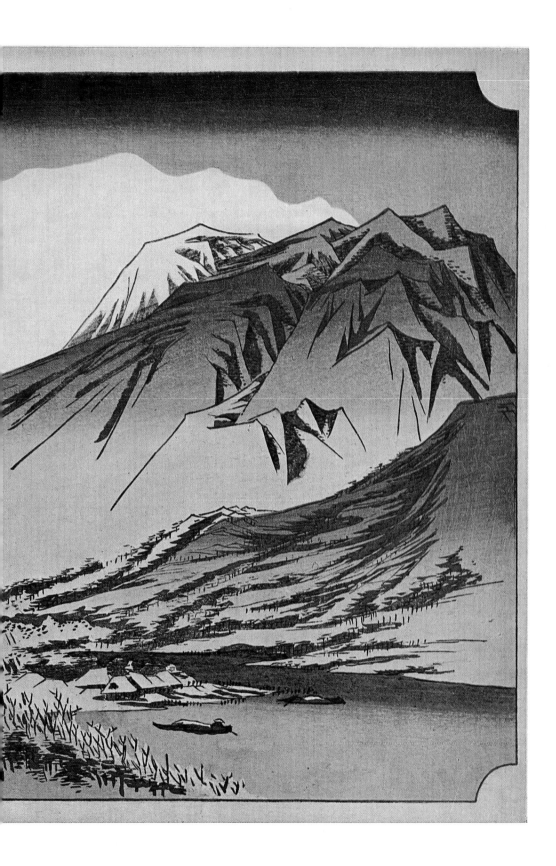

45

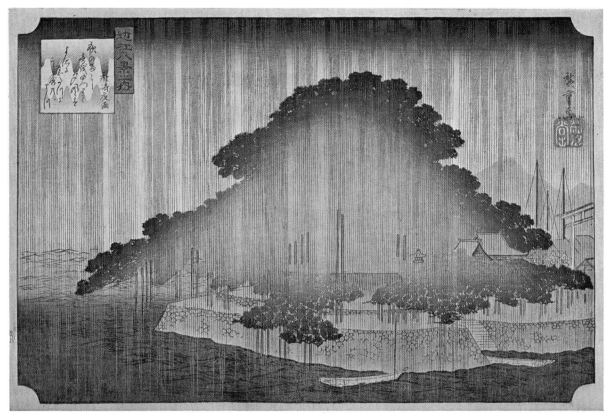

14. *Night Rain at Karasaki,* from *"Eight Views of Ōmi"* ◆ *ōban* ◆ published by Eikyūdō ◆ 1830 ◆ No sign of human life and sheets of dark rain enveloping the old, spreading pine tree makes this a picture of desolation. The old tree has died and today a new pine flourishes in its place.

◁ 13. *Evening Snow at Hira,* from *"Eight Views of Ōmi"* ◆ *ōban* ◆ published by Eikyūdō ◆ 1830 ◆ Though some critics find fault with the foreground perspective and point out that the bright color of the lake does not harmonize with the remainder of the print, I consider this austere landscape to be one of Hiroshige's finest. The white sky area effectively offsets the craggy, masculine mountain peaks.

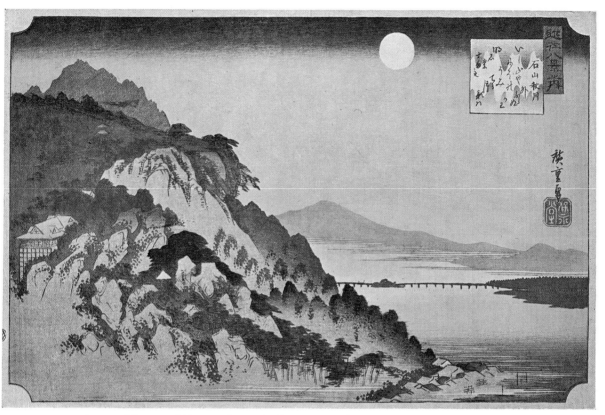

15. *Autumn Moon at Ishiyama,* from *"Eight Views of Ōmi"* ◆ *ōban* ◆ published by Hōeidō ◆ 1830 ◆ This superb landscape, the most elegant of the "Ōmi" series, shows a long bridge running across Lake Biwa, which is silvered in white moonlight. Ishiyama, in the foreground, the location of a famous temple, has often been the subject of sorrowful romances and poems.

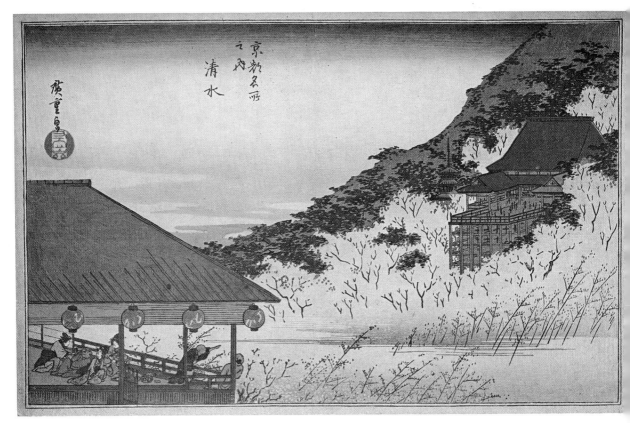

京都名所
之内
清水

16. *Kiyomizu,* from *"Famous Places of Kyoto"* ◆
ōban ◆ published by Eisendō ◆ One of the best-
known places of Kyoto provides the setting for
an amusing and human print. One of the sight-
seers, having tippled too much saké, is causing
the teahouse girls some concern, while a second,
more refined individual points with rapt interest
at the delicately drawn temple and pagoda, afloat
in a pale sea of flowers. The careful workmanship
of this series is of a consistent and high quality.

48

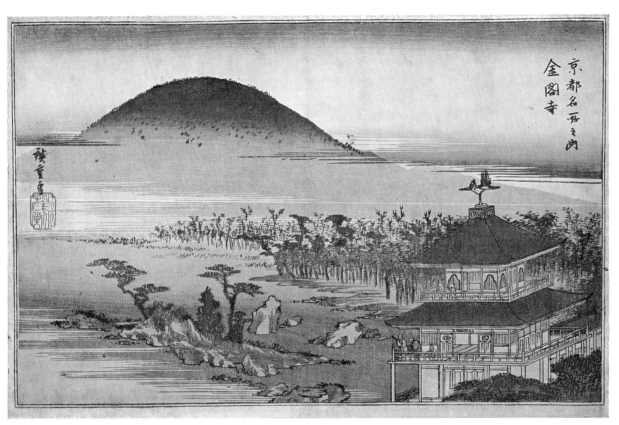

17. *The Kinkaku-ji*, from *"Famous Places of Kyoto"* ◆ *ōban* ◆ published by Eisendō ◆ 1830 ◆ Although today visitors are given a slapdash tape-recorded tour of the outside of this delicate pavilion—and that a reconstruction of recent years—in the past people were able to mount to the top for a good view of the pond.

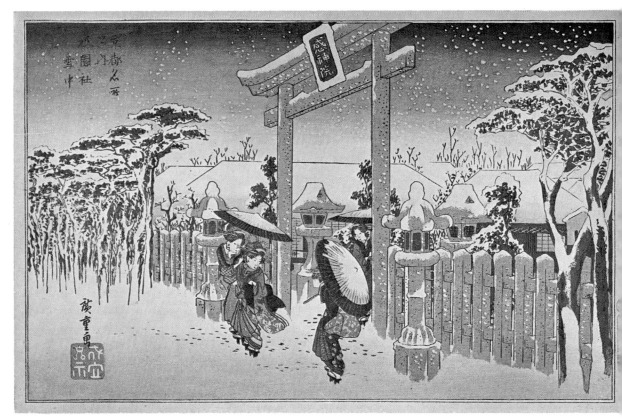

18. *Snowfall at the Gion Shrine,* from *"Famous Places of Kyoto"* ◆ ōban ◆ published by Eisendō ◆ 1830 ◆ The chill blue of the stone gate and fence and the high-piled, downy snow delicately balance the warmth of the group of women talking or laughing between themselves. Hiroshige clearly recognized the effectiveness of woodblock printing to portray snow scenes.

19. *Evening Rain at Tadasugawara,* from *"Famous Places of Kyoto"* ◆ ōban ◆ published by Eisendō ◆ 1830 ◆ Men and women enjoy a drink and smoke inside small shops. Slashing black rain pouring from clouds on the mountain and cutting sharp paths across the reddish sky clearly indicates the sudden nature of the storm. This print brings something of the spirit of Edo into the Kyoto scene, and though it perhaps carries less emotional charge than some of his more poetic works nevertheless, aesthetically this is a very excellent landscape.

20. *A Cool Evening at Shijōgawara,* from *"Famous Places of Kyoto"* ◆ ōban ◆ published by Kawaguchi ◆ 1830 ◆ Kyoto town life and culture centered around the Kamo River and this area around Shijōgawara. There would be a sophisticated atmosphere to moon-viewing parties or groups who watched the giant yearly bonfires. It was an atmosphere of culture and charm, of happiness and sorrow —combinations that were the foundation and the essence of a way of life.

50

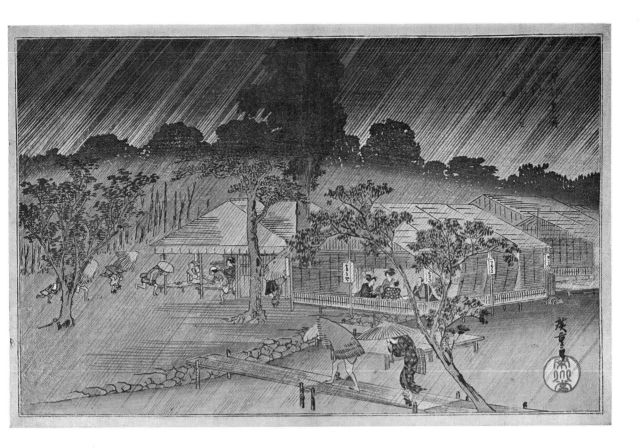

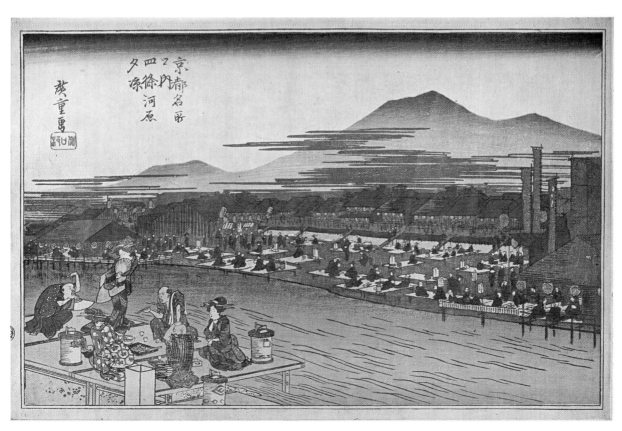

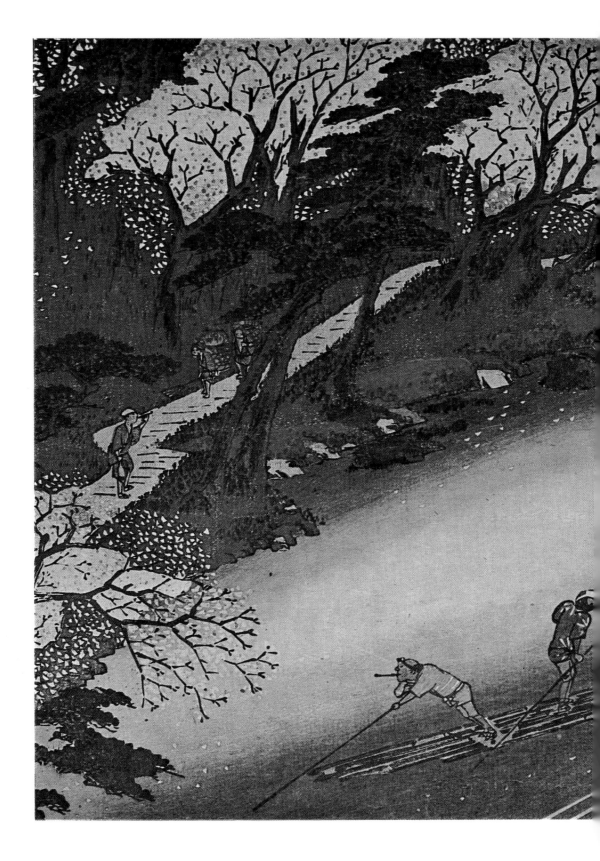

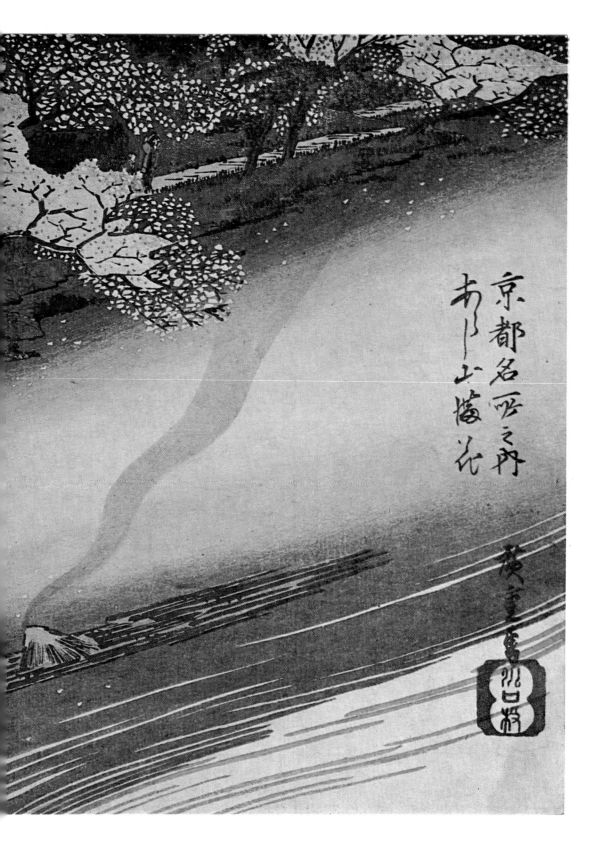

京都名所之内
あらし山満花

広重画

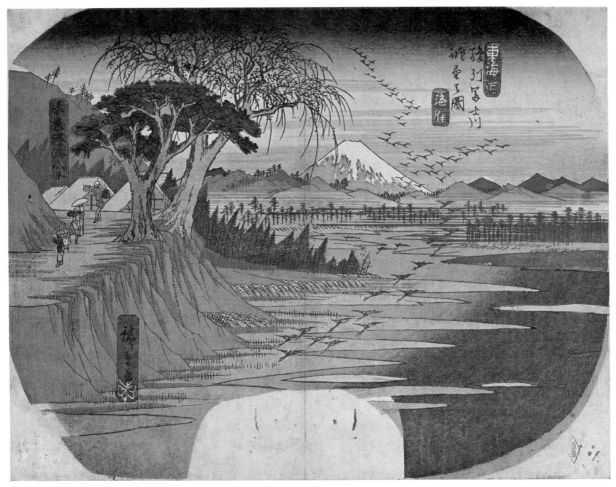

22. *View of Sunsyu Fujigawa,* from *"Eight Views of Hyōri Ekiro"* ◆ fan ◆ published by Dansendō ◆ *ca.* 1840 ◆ Though the general tone of this print is perhaps a little heavy, the glowing evening sky bounded by the indigo upper sky, which is echoed in the river, is particularly beautiful. A zigzag of geese echoes the line of the river. Mass-production has resulted in faulty registration.

◁ 21. *Cherry Blossoms at Arashiyama,* from *"Famous Places of Kyoto"* ◆ ōban ◆ published by Eisendō ◆ 1830 ◆ Arashiyama, a famous Kyoto beauty spot, is almost as magnificent clad in its crimson autumn maples as it is in the cherry blossoms of spring. Hiroshige depicts the cherry blossoms when they are just beginning to wilt and stray leaves float down to the river. A man stops for a smoke on the bank and watches the two boatmen as they pole their way down the river.

54

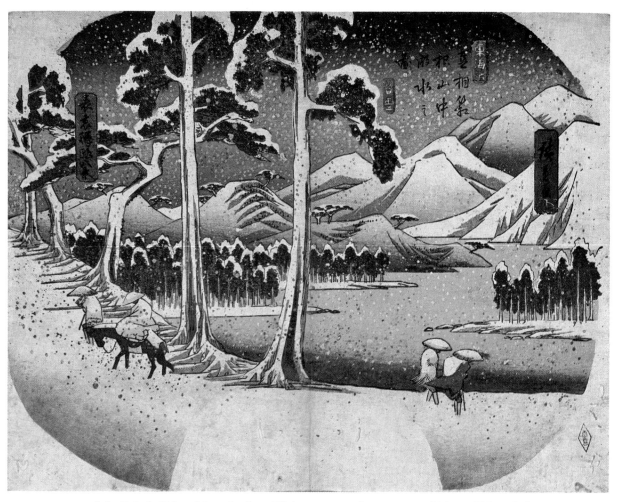

23. *Lakeside in the Hakone Mountains,* from *"Eight Views of Hyōri Ekiro"* ◆ fan ◆ published by Dansendō ◆ middle period ◆ A number of lovely folding fans from the Heian period show aquatic scenes and snowscapes, which would be refreshing to look at in the heat of summer. The chilly mountain scene that Hiroshige depicts here is intended to have the same effect.

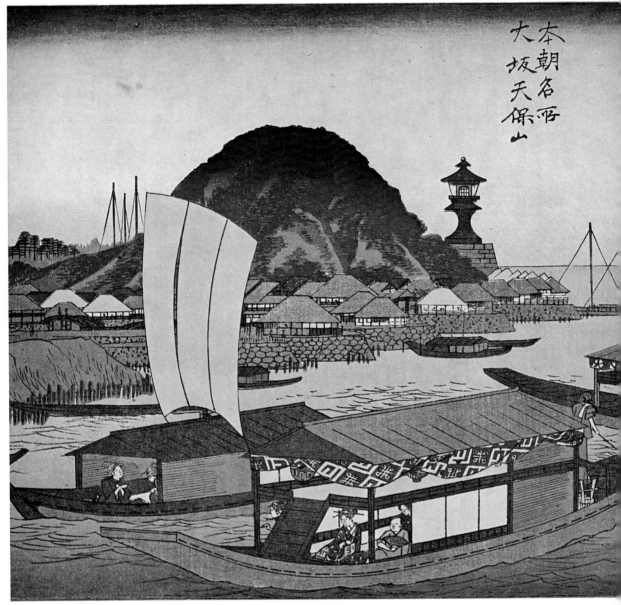

本朝名所
大坂天保山

24. *Osaka Tempōzan*, from *"Famous Scenes of Our Homeland"* ◆ ōban (detail) ◆ published by Fuji-hiko ◆ *ca.* 1840 ◆ Created from dredgings at the mouth of the Aji River, the hill called Tempōzan was to become one of Osaka's leading attractions. Other prints show it bustling with activity during the height of the cherry blossom season. Hiro-shige may have come here down the Yodo River after his trip to Kyoto. Fashionable people of old Naniwa take a cruise in a luxury barge.

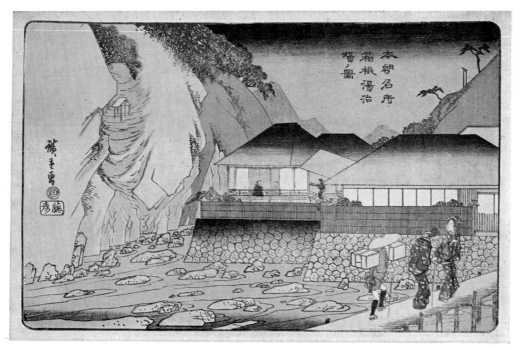

25. *Hakone Spa,* from *"Famous Scenes of Our Homeland"* ◆ *ōban* ◆ published by Fujihiko ◆ *ca. 1840* ◆ Doubtless, in the old days, the trip to Hakone from Edo took some time, but then, as now, it was famous for its hot spring resorts. Many people, including Hiroshige, visited there.

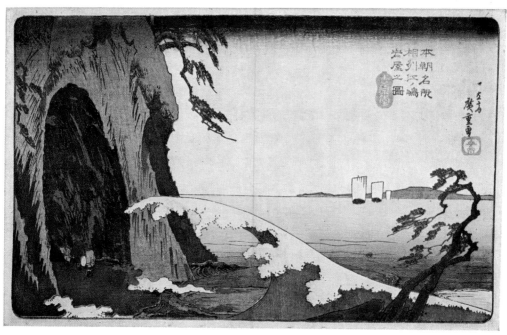

26. *Enoshima,* from *"Famous Scenes of Our Homeland"* ◆ *ōban* ◆ published by Fujihiko ◆ 1830 ◆ Ukiyo-e artists frequently portrayed the Shonan Coast and this was the finest of Enoshima. A leaping white wave joins the light and the dark portions of the print.

57

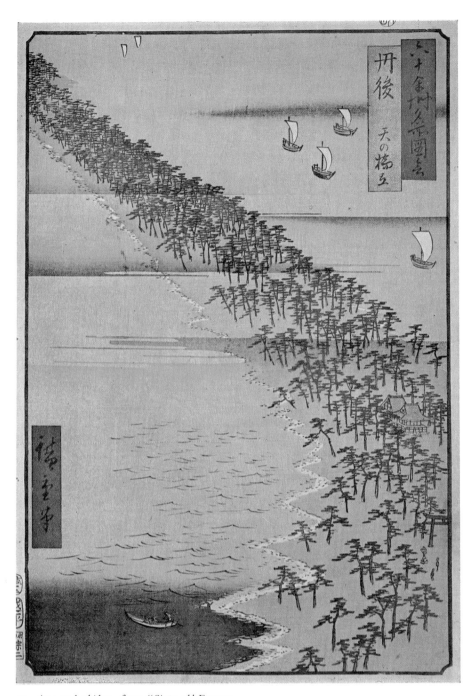

27. *Ama-no-hashidate,* from *"Sixty-odd Famous Places of Japan"* ◆ 1854 ◆ Ama-no-hashidate, a spit of land stretching out into the Japan Sea, is ranked with Miyajima and Matsushima as one of the three most outstanding scenic attractions of Japan.

58

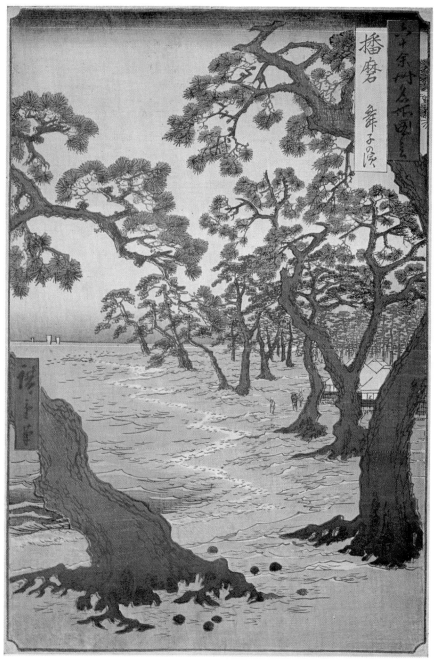

28. *Seashore at Maiko*, from *"Sixty-odd Famous Places of Japan"* ◆ The perspective is especially fine in this print, which was published one year after Hiroshige's death. Though once a famous beauty spot, this area is no longer lovely as it was in Hiroshige's day.

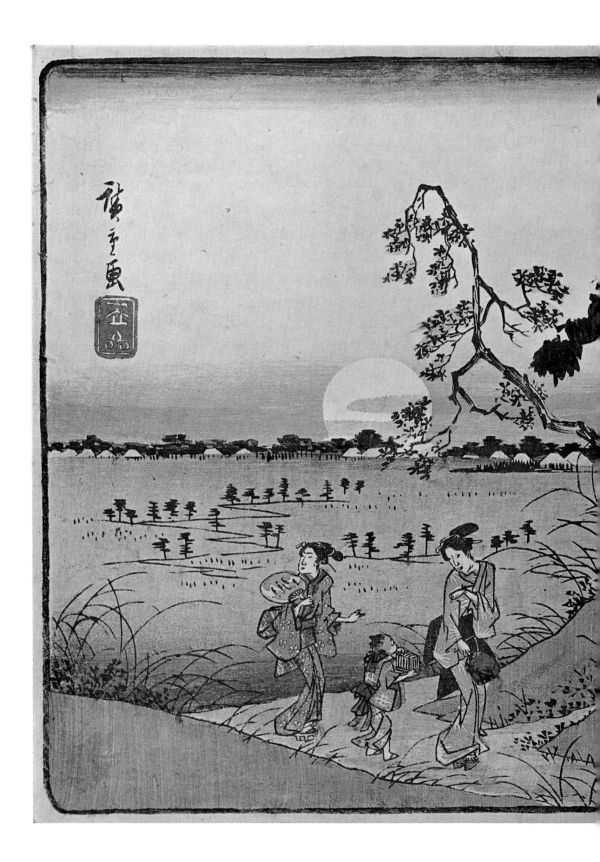

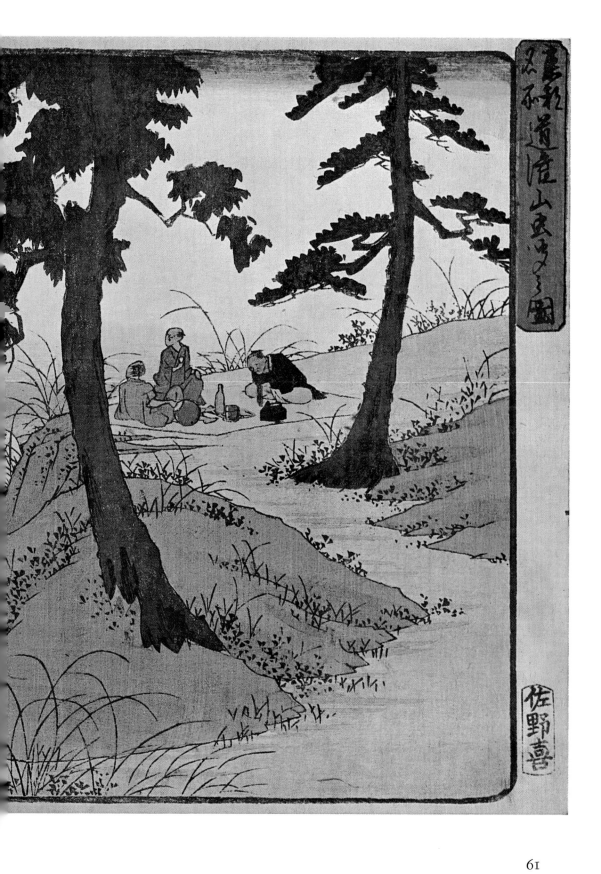

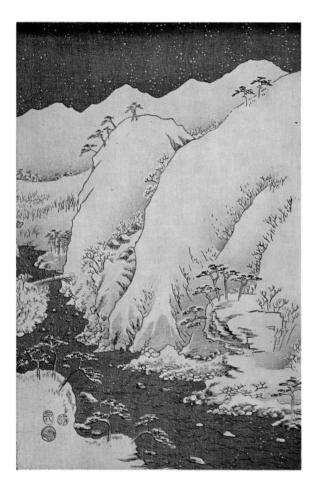
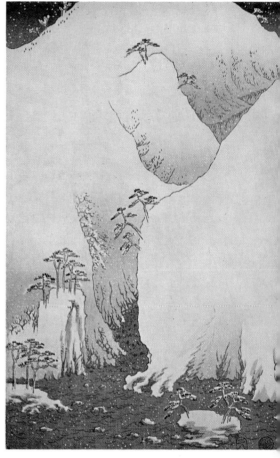

◁ 29. *Song of Insects on Dōkanyama,* from *"Famous Places in the Eastern Capital"* ◆ *ōban* ◆ published by Sanoki ◆ *ca.* 1844 ◆ The Dōkanyama eminence, said to the site of a fortress built by Ōta Dōkan, the first man to build a castle in Edo, was the scene of many elegant outings when people of the town would bring out their saké to enjoy the autumn moon and the singing of the insects. The elegance of this print matches that of these social outings.

62

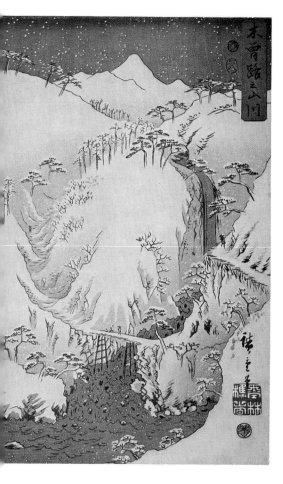

30–31–32. *Mountains and River Along the Kisokaidō* ◆ *ōban* triptych ◆ published by Okazawaya ◆ 1858 ◆ Hiroshige made this print when he was sixty years old, an age when a man would perhaps look back over his life and wonder how worthwhile it had been. Of a mild temperament, Hiroshige had no big plans for the remainder of his life as did Hokusai, who at the age of seventy-five made a new life program: to be a complete artist by the age of one hundred and ten. Yet Hiroshige had lost none of his artistic imagination. This triptych, with the sapphire stream flowing through the vast, snow-bound mountains, is both a symbol of the artist's life and one of his greatest works.

63

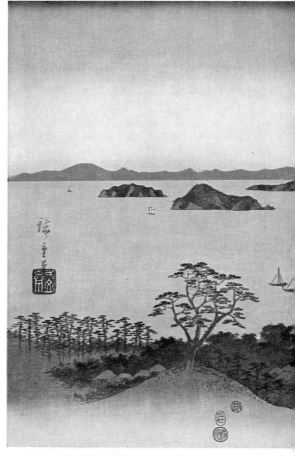

33–34–35. *Moonlight at Kanzawa* ◆ *ōban* triptych ◆ published by Okazawaya ◆ 1858 ◆ This is frequently considered as the greatest of the triptych set. One famous critic praises the drawing of the rolling hills, the fork-lightning spit of land in the center and the scattered, various-sized islands, but contends that the work is made great by the mastery of the perspective, whereby the whole landscape unfolds in one almost surrealistic panorama under the glimmering, hypnotic gaze of the moon.

I feel that this is true. Furthermore the coloring is extremely economical—ink tones, indigo and pale lavender. The elegant moon, crossed by a thin line of geese, fishing boats at anchor and hurrying back to make port before dark, the gloomy reed banks, the approaching night—all the elements of this great work demonstrate to the viewer the emptiness of worldly pleasure.

64

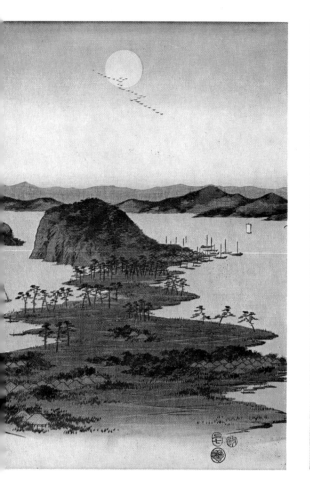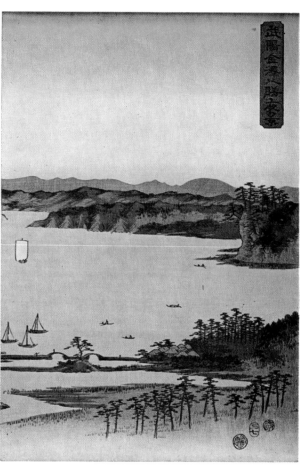

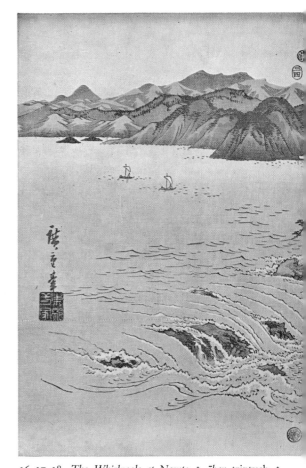

36–37–38. *The Whirlpools at Naruto* ◆ *ōban* triptych ◆
published by the Okazawaya ◆ 1858 ◆ In contrast to the
calm of the Shikoku side, the view from the Awaji island
side of the straits spreads before us in boiling flowerlike
whirls. To achieve such an effect in the medium of the
woodblock print as Hiroshige does in this landscape is a
masterful accomplishment.

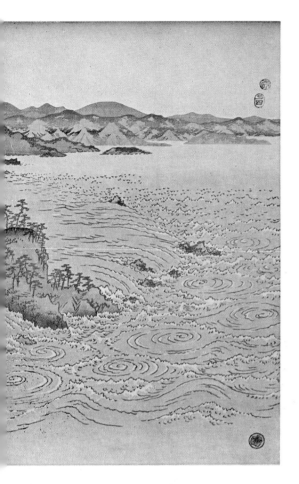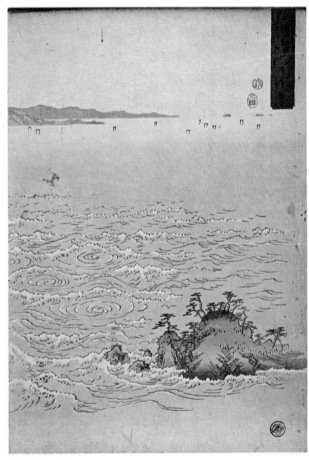

39. *Nihonbashi on a Clear Snowy Morning,* from *"Famous Places of* ▷
Edo" ◆ *ōban* ◆ late years ◆ published by Fujikei ◆ Nihonbashi—the
bridge from which roads in the nation were measured and the pride
of all Edoites. In the middle ground is Chiyoda Castle, the seat of the
ruler of all the lordlings in Japan, and in the distance is the white peak
of Mount Fuji. Both Hokusai and Hiroshige did prints of this
historic scene. This delicate treatment of a popular subject evokes the
mood of Edo and its people. Today, Nihonbashi crouches below the
concrete belt of an expressway, and the spirit that lingers in this
print has died.

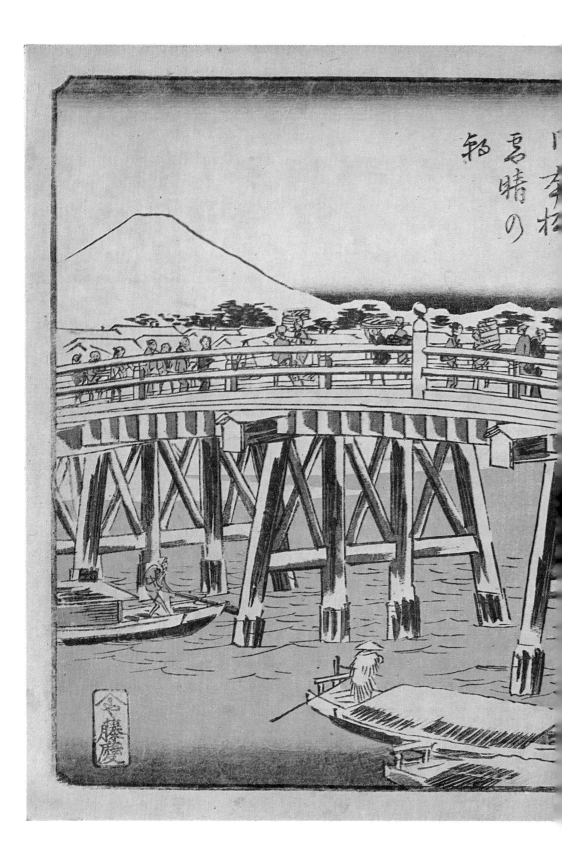

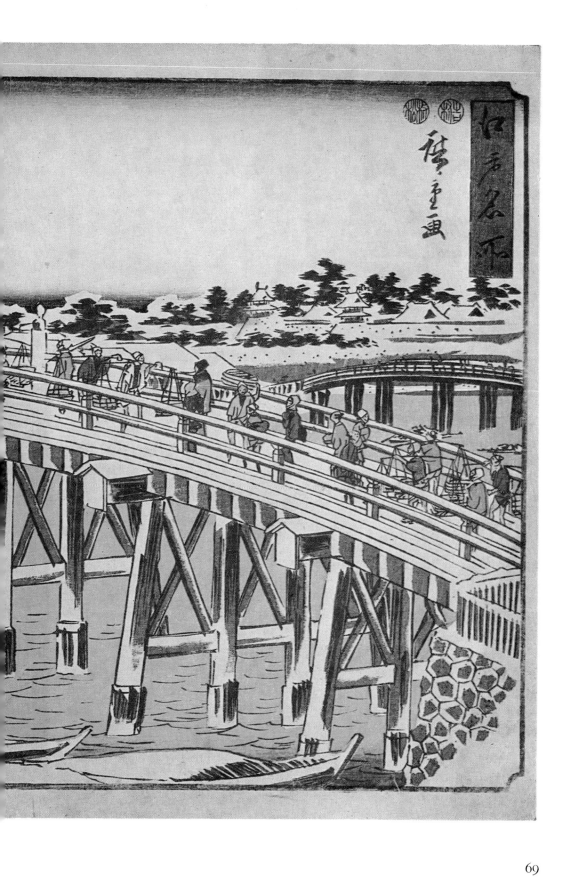

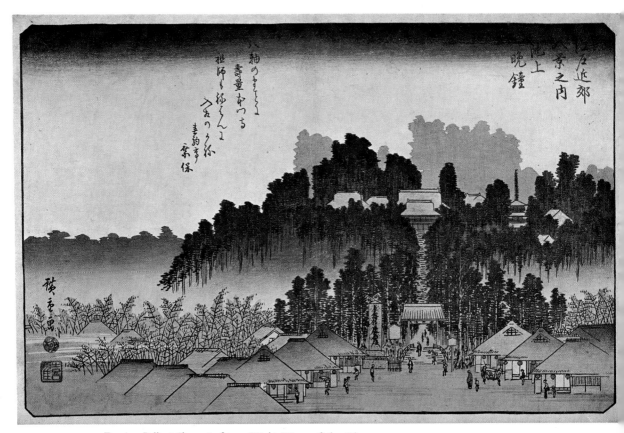

40. *Evening Bell at Ikegami,* from *"Eight Views of the Edo Environs"* ◆ *ōban* ◆ published by Kikakudō ◆ 1838 ◆ All the prints of this series rank among Hiroshige's masterworks. Until World War II a scene very similar to this was still to be enjoyed at Ikegami.

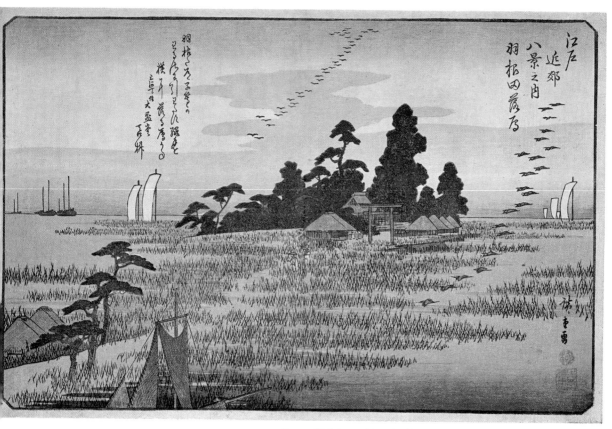

41. *Geese Alighting at Haneda*, from *"Eight Views of the Edo Environs"* ◆ *ōban* ◆ published by Kikakudō ◆ 1838 ◆ Two pilgrims dressed in white and wearing large round hats push their way through reeds on the footpath returning through the cool autumn evening from a visit to a shrine. Geese wheel downward through a glowing sky.

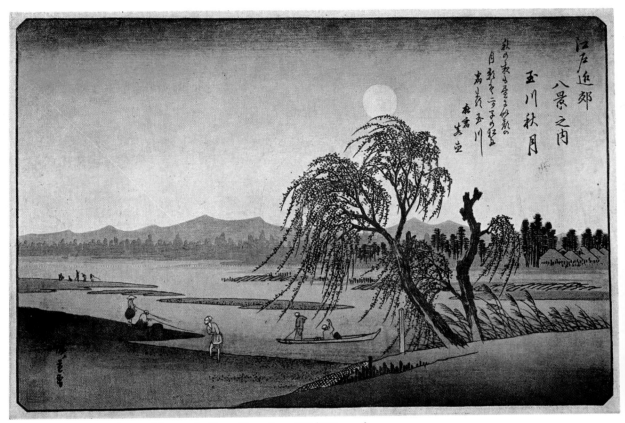

42. *Autumn Moon on the Tama River,* from *"Eight Views of the Edo Environs"* ◆ published by Kikakudō ◆ 1838 ◆ Melancholy and serene, the placid surface of the Tama River catches the crystal light of the slowly mounting moon. The wind rustles through the tips of the willow boughs. This print is probably the finest of the series.

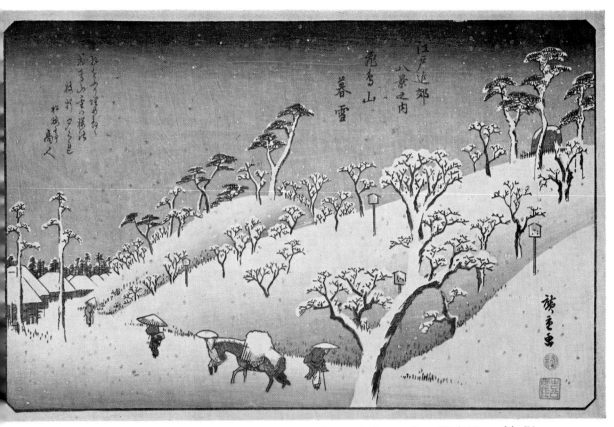

43. *Evening Snow at Asukayama*, from *"Eight Views of the Edo Environs"* ◆ ōban ◆ published by Kikakudō ◆ 1838 ◆ The light gray of the hills and the sky reflect a time when flowers have died and geese have flown, leaving behind only the whirling snow that whitens the oncoming night.

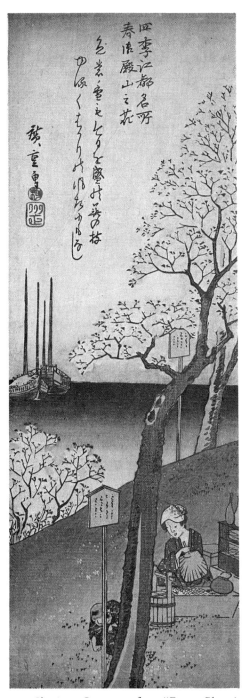

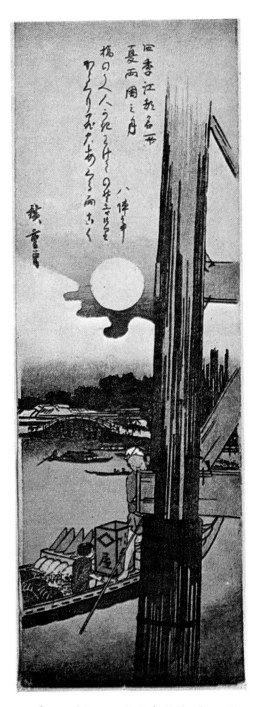

44. *Cherries at Gotenyama*, from *"Famous Places in Edo in All Four Seasons"* ◆ *chū-tanzaku* ◆ published by Kawashō ◆ 1835 ◆ This view is similar to one used by Hokusai. A rough translation of the poem is: "Not even a breeze rustles the full-blossomed boughs."

45. *Summer Moon over Ryōgoku Bridge*, from *"Famous Places in Edo in All Four Seasons"* ◆ *chū-tanzaku* ◆ published by Kawashō ◆ 1835 ◆ Among the night traffic of the river a lone melon seller with his son poles his bark under the bridge. The poem says: "Lovely fireworks, if you can push through the sightseers on the bridge for a glimpse."

74

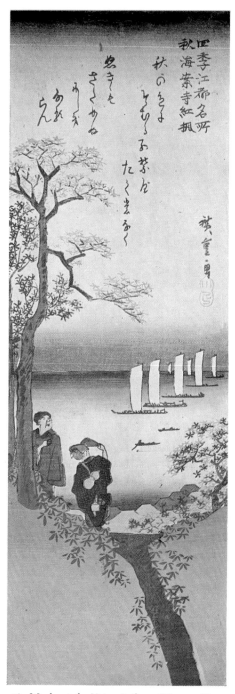

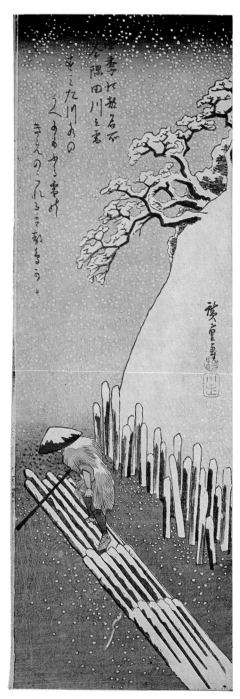

46. *Maples at the Kaian-ji,* from *"Famous Places in Edo in All Four Seasons"* ◆ *chū-tanzaku* ◆ published by Kawashō ◆ 1835 ◆ This print evokes the beauty of autumn. As the poem tells us: "On the trees or scattered on the ground, brocade-like maples."

47. *Snow on the Sumida River,* from *"Famous Places in Edo in All Four Seasons"* ◆ *chū-tanzaku* ◆ published by Kawashō ◆ 1835 ◆ Each of the four pictures in this series display Hiroshige's mastery of space. This portrait of winter, with its deep-blue snow, and gray and black sky, reveals the finest color harmony of them all. The poem: "Snowdrops linger on the Sumida . . . true birds of Edo."

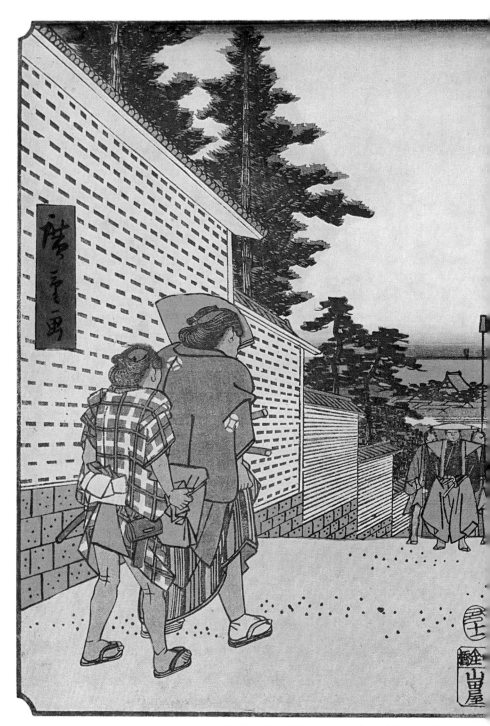

48. *View from Kasumigaseki*, from *"Famous Places in Edo"* ◆ *ōban* ◆ published by Yamadaya ◆ 1854 ◆ Women shade themselves from the hot summer sun with parasols as they pass a weighty sumo wrestler. On one side of the road stands the mansion of the powerful

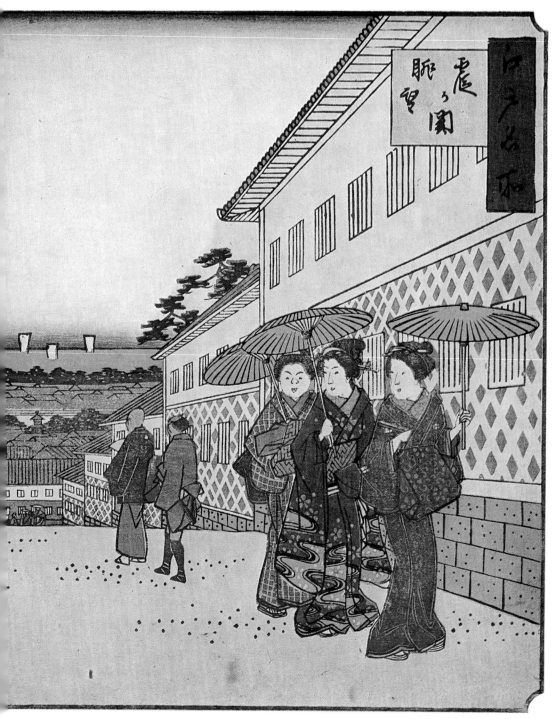

Asano family and on the other that of the Kuroda family. It is said that the barrier gate to the highway leading to the northeast provinces once stood here. Before World War II this slope and black tile and white plaster *namako* walls remained in the area, but by then, of course, the sails dotting the bay in the distance were not visible. Today the Diet Building stands at this spot. The "One Hundred Views of Famous Places in Edo" contains a print of the same view, depicting kite-flying during the New Year holiday.

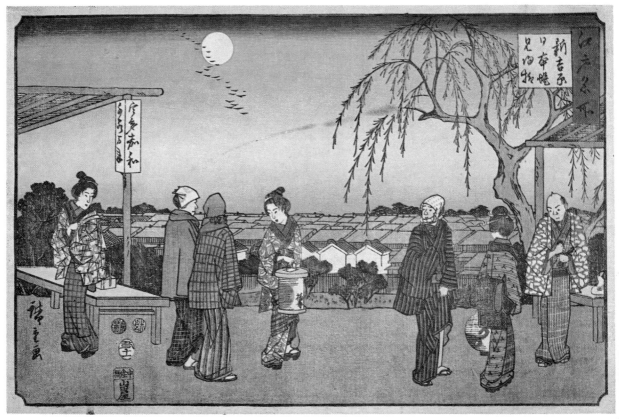

49. *Willow on Nihon Embankment, Shin-Yoshiwara,* from *"Famous Places in Edo"* ◆ *ōban* ◆ published by Yamadaya ◆ 1854 ◆ Those leaving the pleasure quarters of Yoshiwara stop and look back from this famous willow tree. Geese cutting a jagged pattern across the blue bands of the moonlit sky and a serving girl lighting the path of the teahouse customers approaching the tree evoke a feeling reminiscent of another, more peaceful age. Kabuki sets pale in comparison.

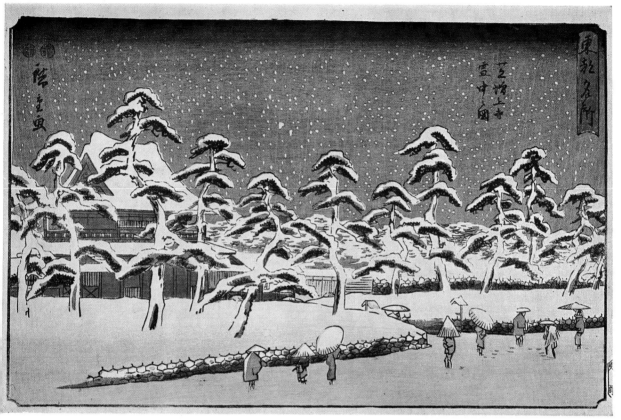

50. *The Shiba Zōjō-ji in the Snow*, from *"Famous Places in the Eastern Capital"* ◆ ōban ◆ published by Marushō ◆ 1848 ◆ This print of the vermilion Zōjō-ji gate surrounded by green pines cloaked in snow is quite wonderful. Sadly, this temple is hemmed in from all sides by buildings today and only a few straggling trees stand in place of the stately pines of the print. The Zōjō-ji was at one time a vast temple that enjoyed the patronage of the Emperor Komatsu II and later became the largest of the eighteen famous temples of the Jōdo sect in the Kantō region.

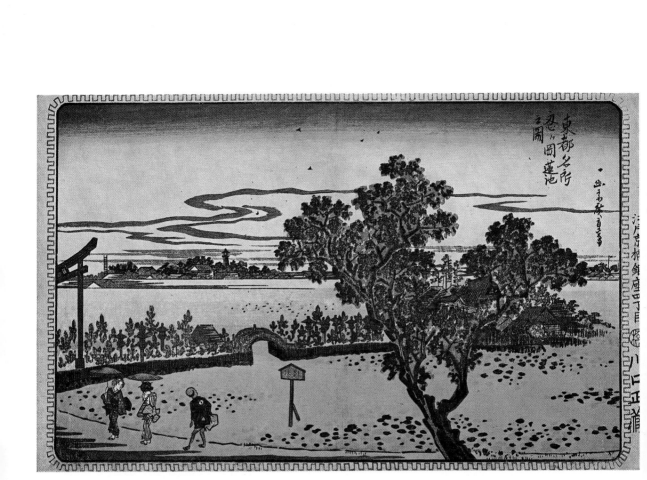

51. *The Lotus Pond at Shinobugaoka,* from *"Famous Places in the Eastern Capital"* ◆ *ōban* ◆ published by Kawaguchi ◆ 1832 ◆ The line and feeling of this early series are immature, but there is a promising freshness in the design. The blood-red clouds are particularly impressive.

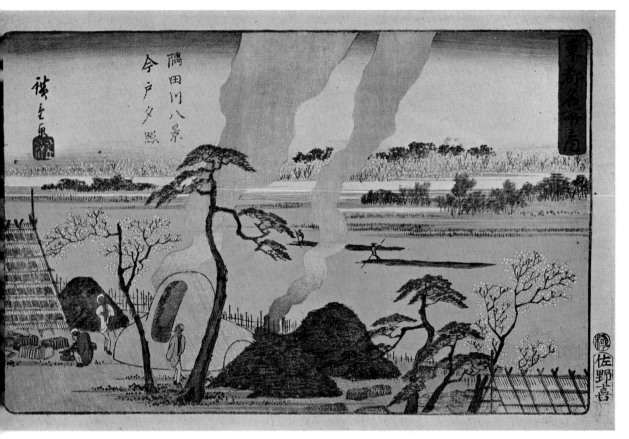

52. *Sunset at Imado, from "Famous Places in the Eastern Capital"* ◆ *aiban* ◆ published by Sanoki ◆ 1842 ◆ Two columns of smoke rising into the early evening springtime sky from tile kilns of the river bank bind this exquisite piece into a solid unit. The red of the flames against the blue river and the white of the springtime flowers accentuate the tones of the print.

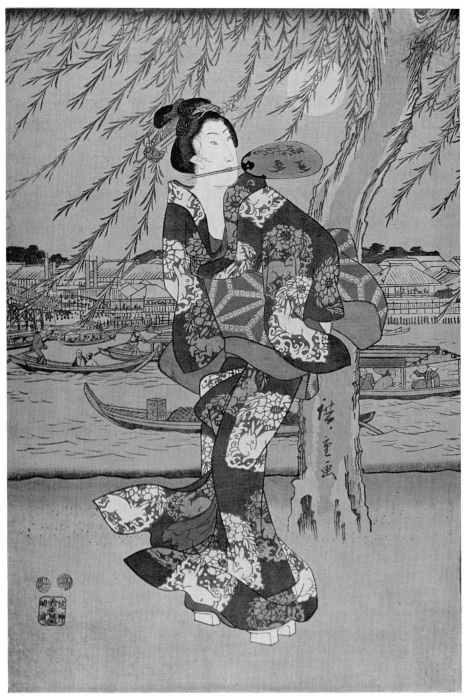

53–54. *Evening Promenade* ◆ two prints from *ōban* triptych ◆ published by Wakasaya ◆ *ca.* 1850 ◆ Utamaro's prints of this sort of subject are collectors' treasures. A cool breeze traces patterns on the water and ruffles the summer kimonos of these ladies of pleasure. The rabbits in the kimono pattern become part of the subject. Men watch from the boats on the river.

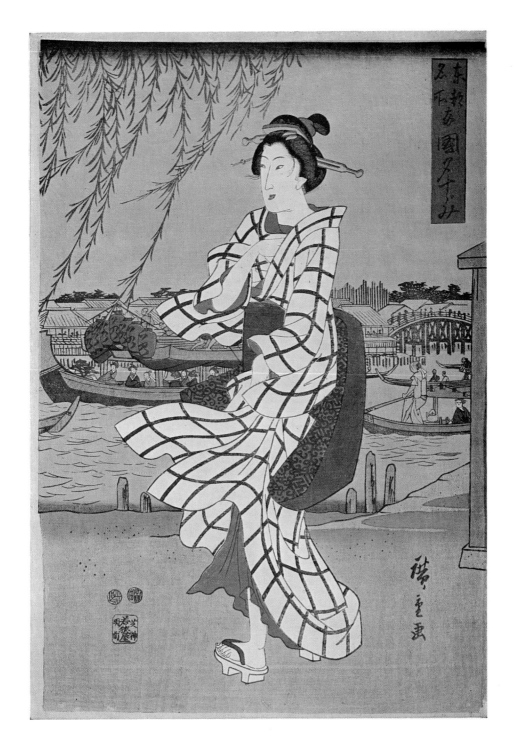

55. *Moonlight at Ryōgoku,* from *"Famous Places in the Eastern Capital"* ◆ *ōban* ◆ published by Kawashō ◆ 1832 ◆ This idea is probably not Hiroshige's original, since Utamaro and Hokusai did drawings of a similar composition, but the treatment is distinctively that of Hiroshige.

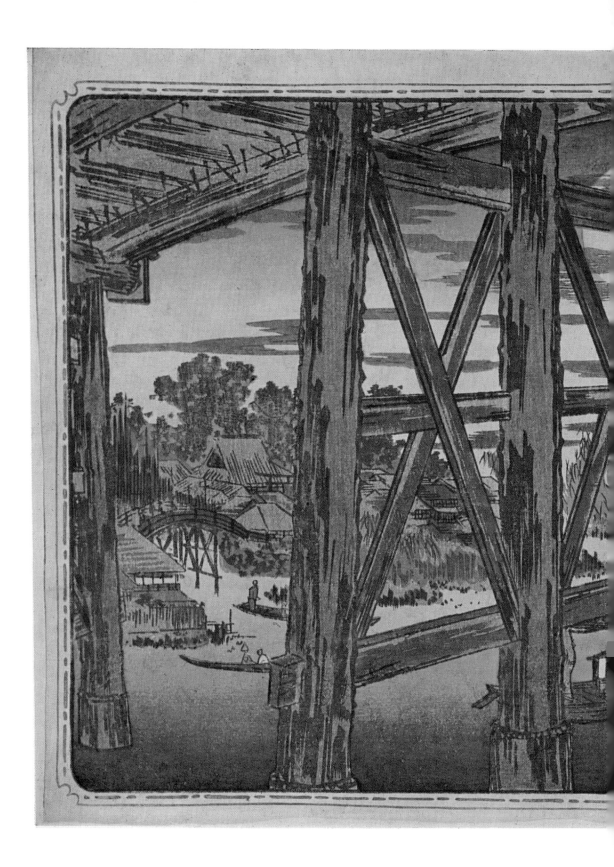

84

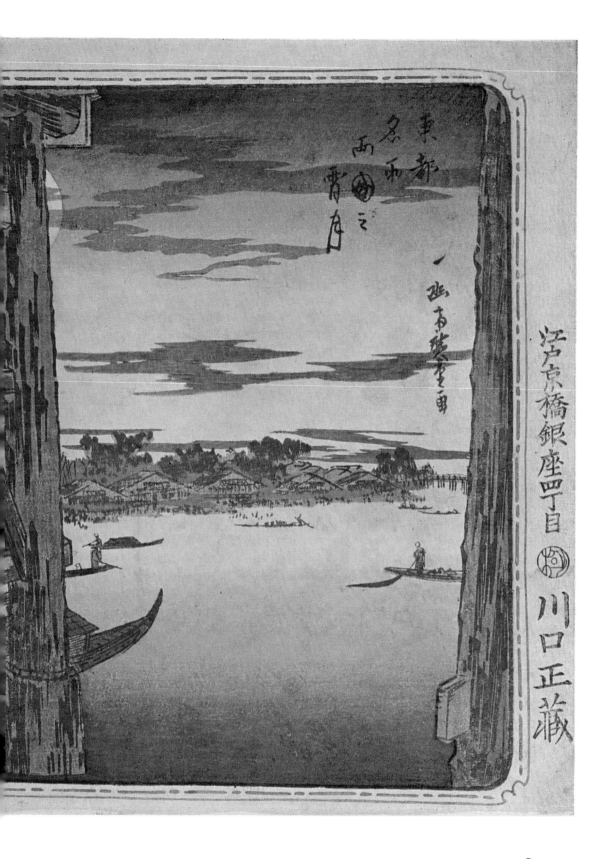

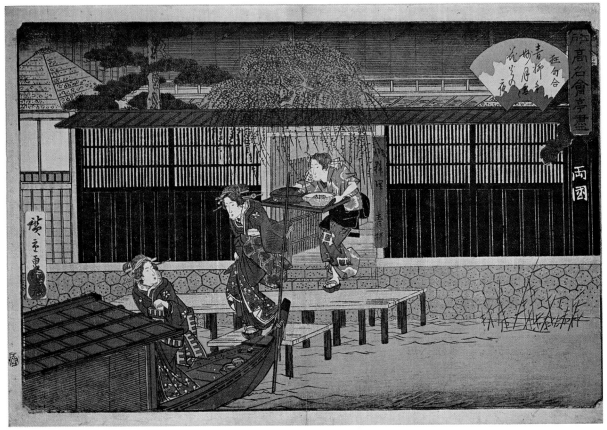

56. *Ryōgoku Aoyagi* ◆ *ōban* ◆ published by Fuji-
hiko ◆ 1839 ◆ Two ladies of pleasure and their
waiting women load fine foods onto a boat for
a moonlight excursion on the Sumida River. The
effect of their gay costumes against the black of
the lattice both startles and pleases.

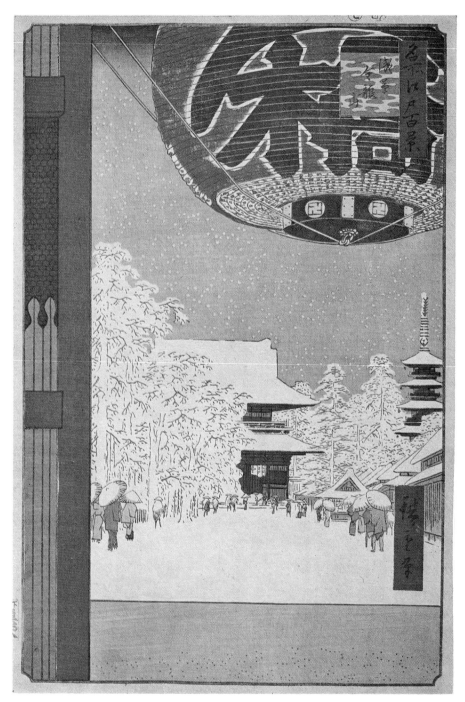

57. *The Asakusa Kinryūzan Temple*, from *"One Hundred Views of Famous Places in Edo"* ◆ ōban ◆ published by Uwoei ◆ 1857 ◆ The main hall of the temple and the pagoda, resplendent in vermilion and half hidden by snow-swatched trees, is framed by the temple gate and a large paper lantern. If "Squall at Ōhashi" is the best of this series, this certainly comes second.

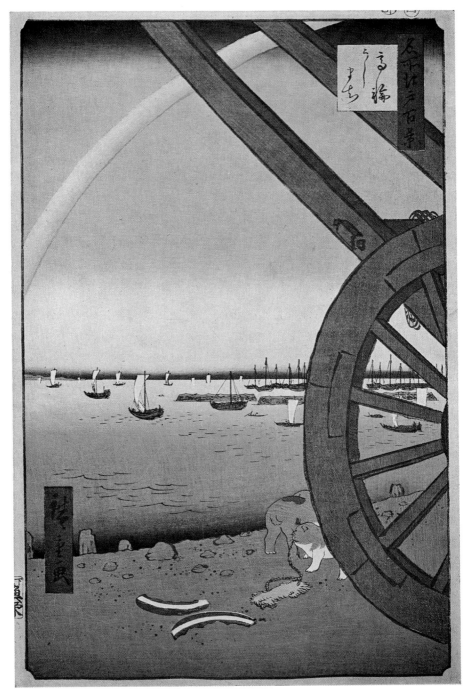

58. *Takanawa Ushimachi*, from *"One Hundred Views of Famous Places in Edo"* ◆ ōban ◆ published by Uwoei ◆ 1858 ◆ Takanawa is in the southern part of Tokyo near Haneda, the site of the present international airport. There were more famous places in this area which Hiroshige chose not to portray. Instead, he gives us this charming picture of a large wagon wheel and traces crisscrossing with a rainbow, creating a fine composition.

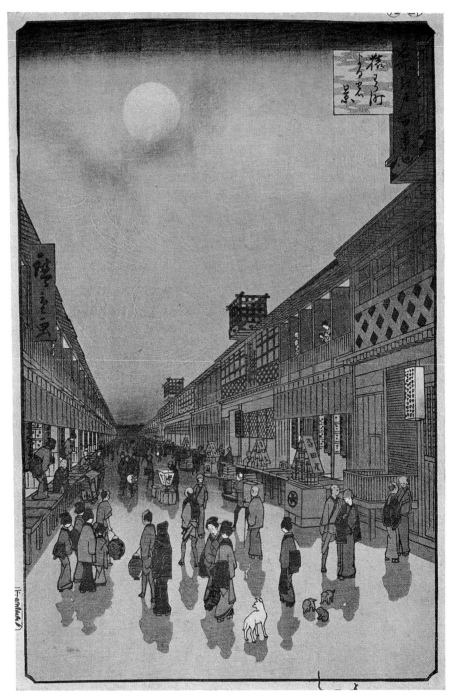

59. *Nighttime in Saruwaka-chō, from "One Hundred Views of Famous Places in Edo"* ◆ *ōban* ◆ published by Uwoei ◆ 1857 ◆ In another of the finest prints in the series, Hiroshige gives us a bustling night view of the theater district hemmed in behind the famous pleasure quarter, Yoshiwara, and the large Asakusa temple, Kinryūzan. Silver light from the moon and the deep blue of the sky intensify the sense of depth and perspective.

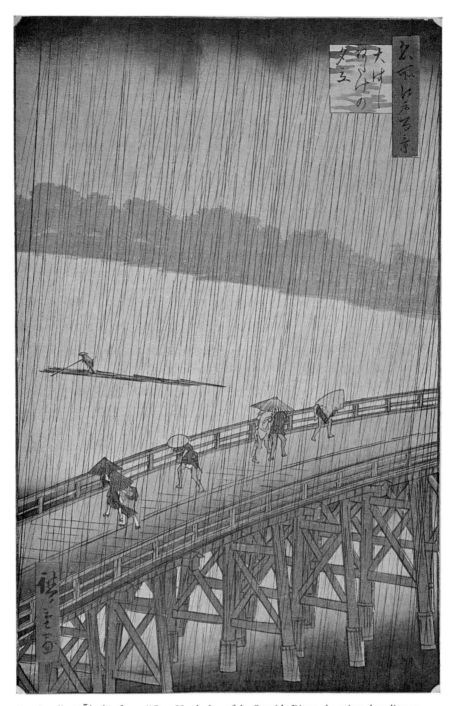

60. *Squall at Ōhashi*, from *"One Hundred Views of Famous Places in Edo"* ◆ *ōban* ◆ published by Uwoei ◆ 1858 ◆ Published almost exactly one year before Hiroshige died, this is one of the pinnacles of his art. The clouds massing above the pale green of the Sumida River, the misty shoreline on the far bank of the river, the solid grid of rain and the crouching figures—these are part of the reason why Hiroshige has succeeded, probably better than any other artist to capture the spirit of rain.

90

62. *Cherry-blossom Day in Yoshiwara Nakanochō,* from *"Famous Places in Edo"* ◆ published by Marujin ◆ The Yoshiwara area operated as a pleasure quarter under the license of the Tokugawa shogunate, and in its day absorbed much of the time and money of the men of the town. This print captures the glory of an early spring day when the cherries are in full bloom and the queenly courtesans take the air.

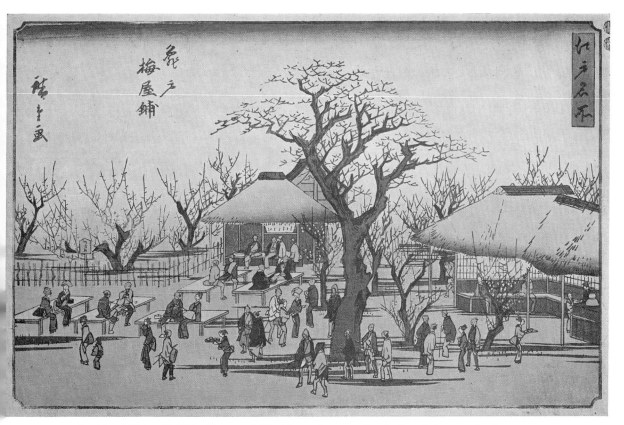

61. *Kameidō Ume-Yashiki* ◆ ōban ◆ published by Fujikei ◆ 1854 ◆ This garden was famous for its double-petaled plum blossoms. People with literary taste would come to the garden, which was about two hundred yards long, and write poems under the gnarled old trees. The teahouse remained until the end of the Meiji period, but now only a small stone plaque stands there.

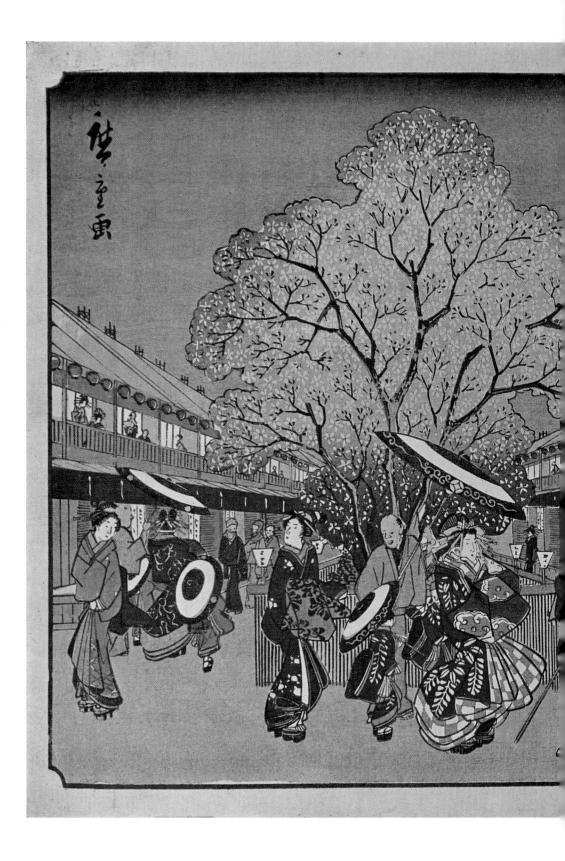

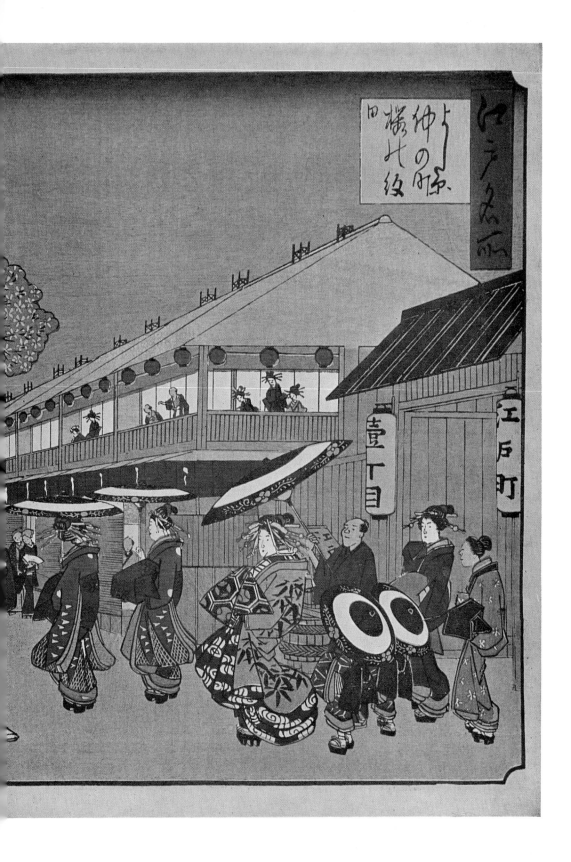

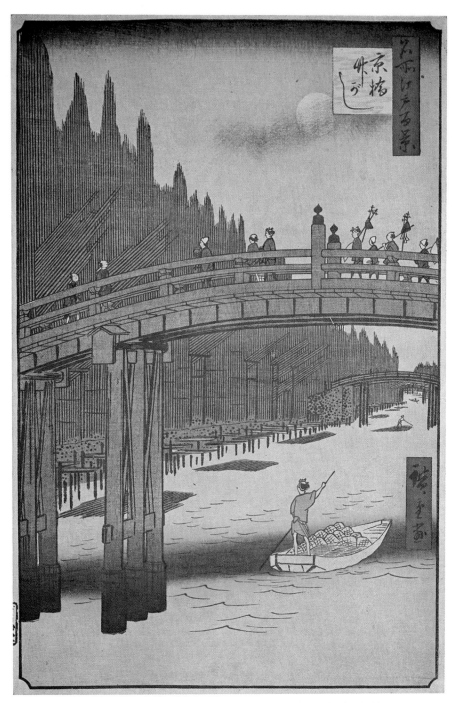

63. *Kyōbashi Bamboo Market,* from *"One Hundred Views of Famous Places in Edo"* ◆ *ōban* ◆ published by Gyoei ◆ 1858 ◆ Boats from all over Japan brought supplies to this bamboo market, which operated on a small scale until the 1930's. The spindly bamboos, useful for construction work in Hiroshige's day, rise up from the bank like a gigantic palisade and tower over the wooden bridge, their tips higher than the moon. The blue-black crisscross of the bamboos and the white moon smudged by a whisp of cloud makes this another of Hiroshige's fine depictions of a night scene.

94

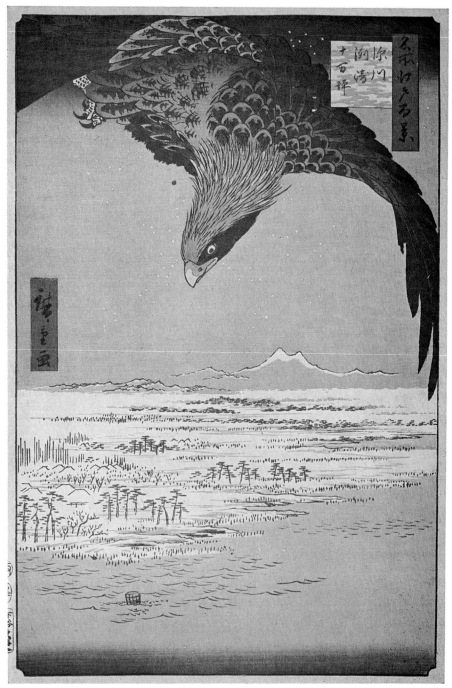

64. *Susaki Jūmantsubo,* from *"One Hundred Views of Famous Places in Edo"* ◆ *ōban* ◆ published by Uwoei ◆ 1858 ◆ The large black eagle, which effectively creates an impression of height, embraces between his wings a snow-bound swampy waste that was, incidentally, to become the home of the gay quarter when it was forced out of the heart of the city. The view of the mountains in the distance is similar to that from the top of Tokyo Tower.

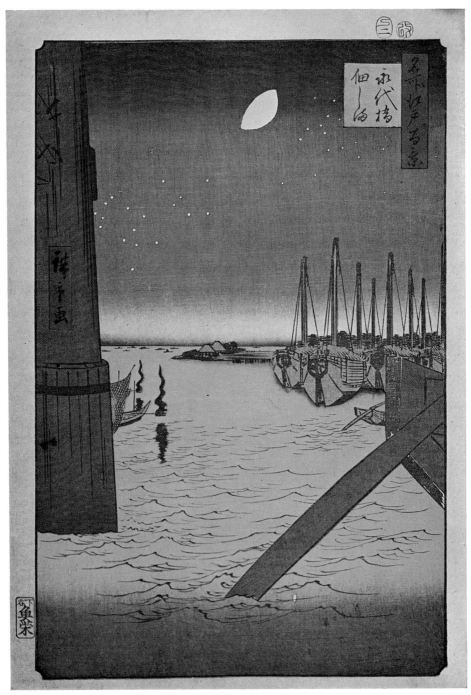

65. *Eitai Bridge at Tsukuda Island,* from *"One Hundred Views of Famous Places in Edo"* ◆ ōban ◆ published by Uwoei ◆ 1858 ◆ Moonlight silvers the masts and ships lying at anchor, and stars dust the indigo sky. Just behind the pile of the bridge the fires used to attract fish to the surface snake their shadows across the waves. The woodblock print is better suited than any other medium to capture the evening mood of scenes of this sort.

96